BRADFORD
IN PHOTOGRAPHS

DAVE ZDANOWICZ

AMBERLEY

First published 2021

Amberley Publishing
The Hill, Stroud
Gloucestershire, GL5 4EP

www.amberley-books.com

Copyright © Dave Zdanowicz, 2021

The right of Dave Zdanowicz to be identified as the Author of this work has been
asserted in accordance with the Copyrights, Designs and Patents Act 1988.

ISBN 978 1 3981 0303 0 (print)
ISBN 978 1 3981 0304 7 (ebook)

British Library Cataloguing in Publication Data.
A catalogue record for this book is available from the British Library.

Typesetting by SJmagic DESIGN SERVICES, India.
Printed in the UK.

FOREWORD BY VISITBRADFORD.COM

Dave Z, in his own distinctive style, captures the iconic landmarks and landscapes of Bradford, a book filled with stunning images, uncovering the beauty of Bradford. Every one of these places has its own interesting story to tell. We urge you to discover them all ... and we invite you to share our passion for the city.

visitbradford.com

ACKNOWLEDGEMENTS

Thank you to my amazing family (Mum and Dad, Treacy, Jack and Oscar) and friends for your help and support making this book. A special thank you to Visit Bradford for writing the foreword for the book. I really appreciate your kind words.

Thank you to Kenko Tokina, Hoya, Vanguard, Lume Cube, Pluto Trigger and TOG24.

I would also like to thank the following people and organisations: Intro 2020, Karen Shaw and Alex Cowland from *Northern Life* magazine, Emma Clayton and the Bradford *Telegraph & Argus*.

I would like to thank Bradford Council for supporting my work. Rizwana and Imran from Royds Hall Manor, Len Palmer and John Coulton at Bradford Council, Michael Shackleton and Bradford City FC, Su Holgate and Vicky Leith from Bradford Theatres, Natalie Everett and Bradford Museums, The National Trust and East Riddlesden Hall, Bradford Grammar School, Bradford Waterstones and The Midland Hotel

A huge thanks to my followers on Facebook, Twitter and Instagram. I really appreciate you all taking the time to view and share my photography.

ABOUT THE PHOTOGRAPHER

Born and raised in Bradford, West Yorkshire, Dave Zdanowicz is a landscape photographer who is very proud of his home city.

Dave has achieved a lot so far in his photography career. He has provided images for a number of books, as well as images to major TV networks including BBC, ITV and Sky, and his pictures have regularly been published nationally and internationally in newspapers and magazines.

Website: www.davezphotography.com
Facebook: www.facebook.com/davezphoto
Twitter: @davez_uk
Instagram: @davez_uk
Email: info@davezphotography.com

INTRODUCTION

It is a great honour to release *Bradford in Photographs*. The images in this book have been captured and selected from my vast adventures in and around the city over the last few years.

I was over the moon when Amberley suggested a photographic book on my home city of Bradford. I really wanted to show the city and the surrounding areas in a positive light and showcase some of the best locations. I hope it inspires people to visit the area and local residents to explore some of our wonderful landmarks.

In the course of taking these photographs I have explored moors and hills, reservoirs and parks, and cliffs and villages throughout the city. Each picture represents a unique moment, captured at a particular time of the year.

It has been a pleasure revisiting some of my favourite destinations around the city as well as discovering new places for the first time. Whatever the weather, whatever the time of year, Bradford is a fantastic place to explore.

I hope you enjoy the book.

Dave Zdanowicz

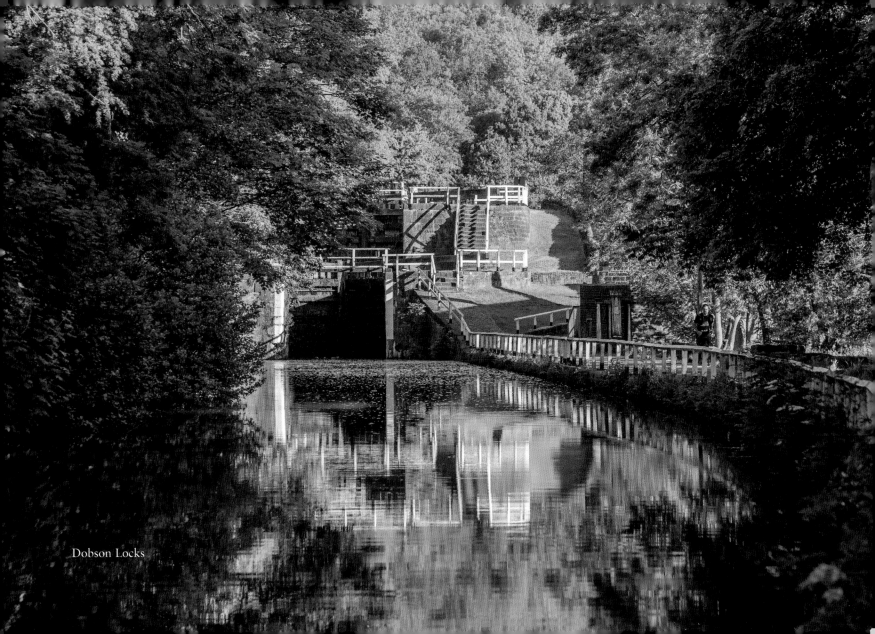
Dobson Locks

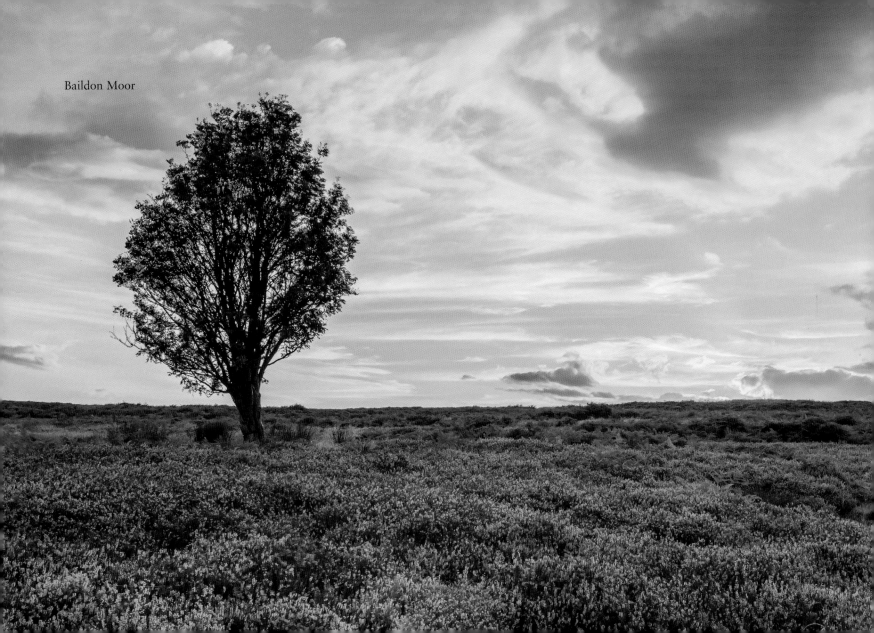

Baildon Moor

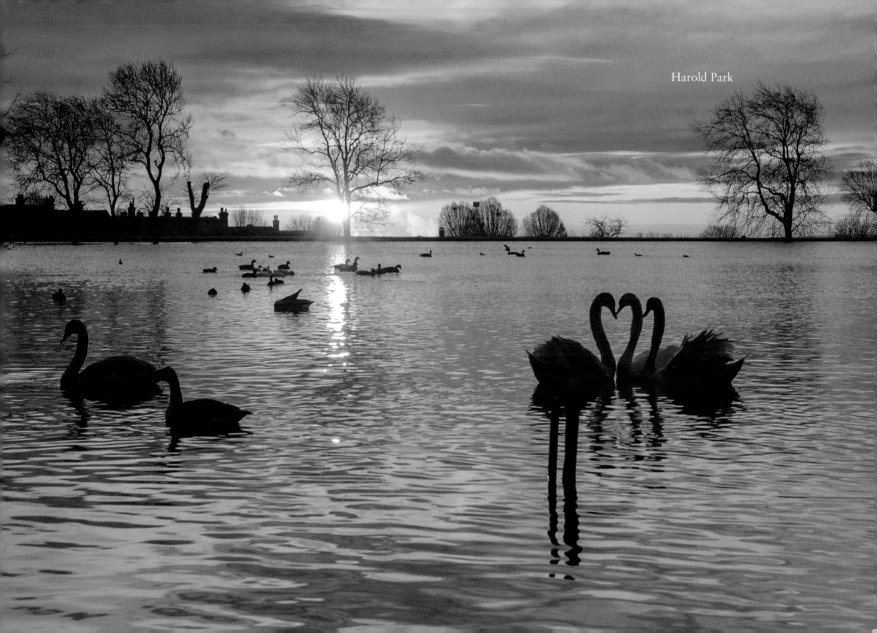

Harold Park

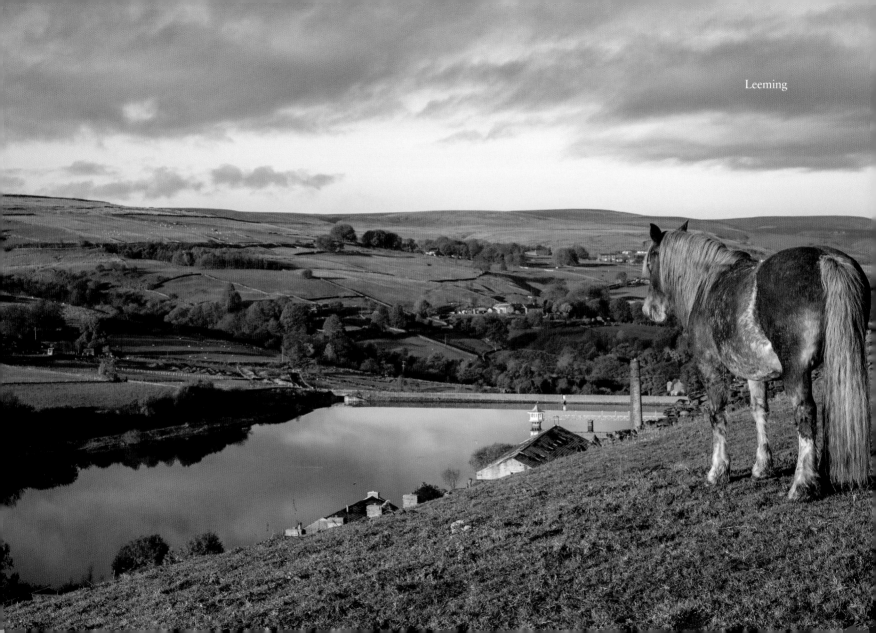

Leeming

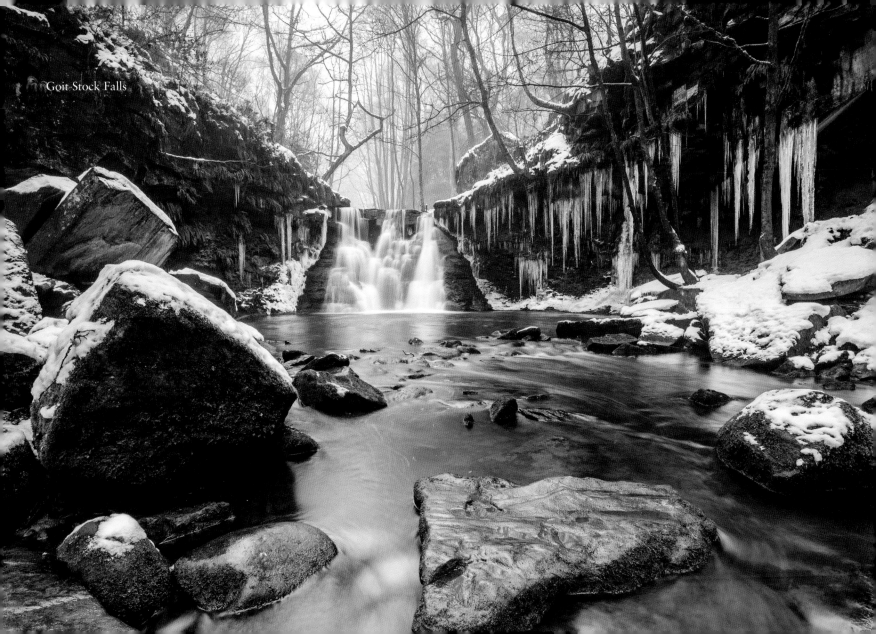

Goit Stock Falls

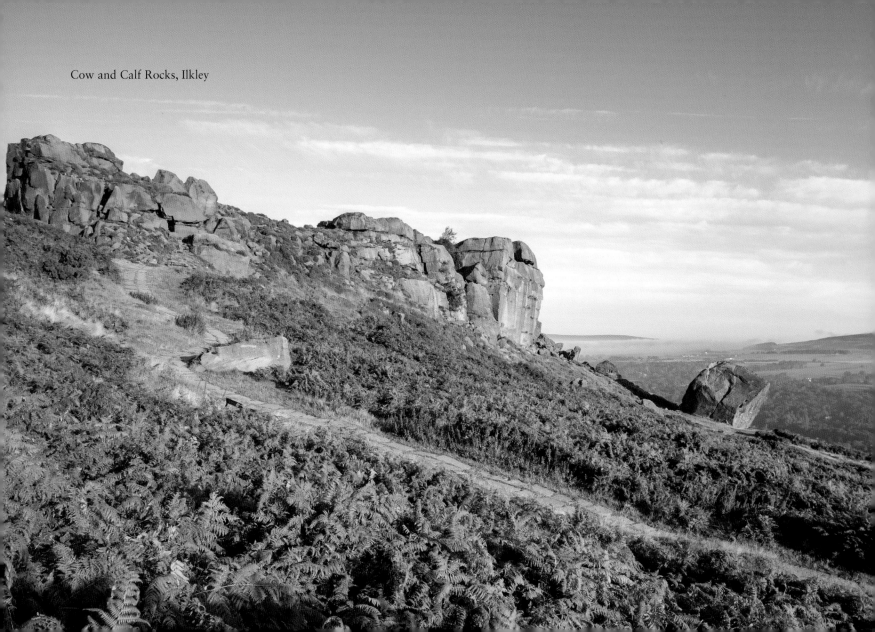

Cow and Calf Rocks, Ilkley

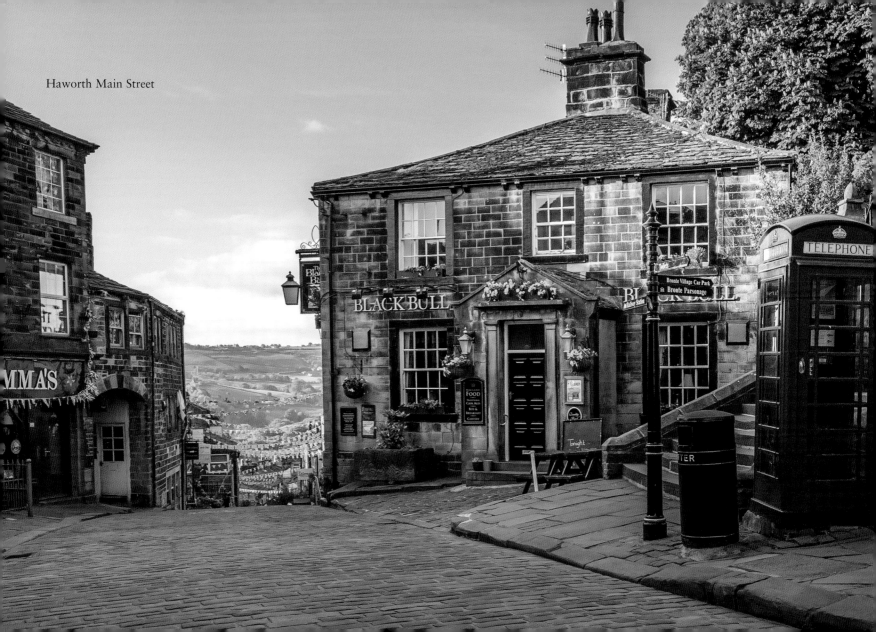

Haworth Main Street

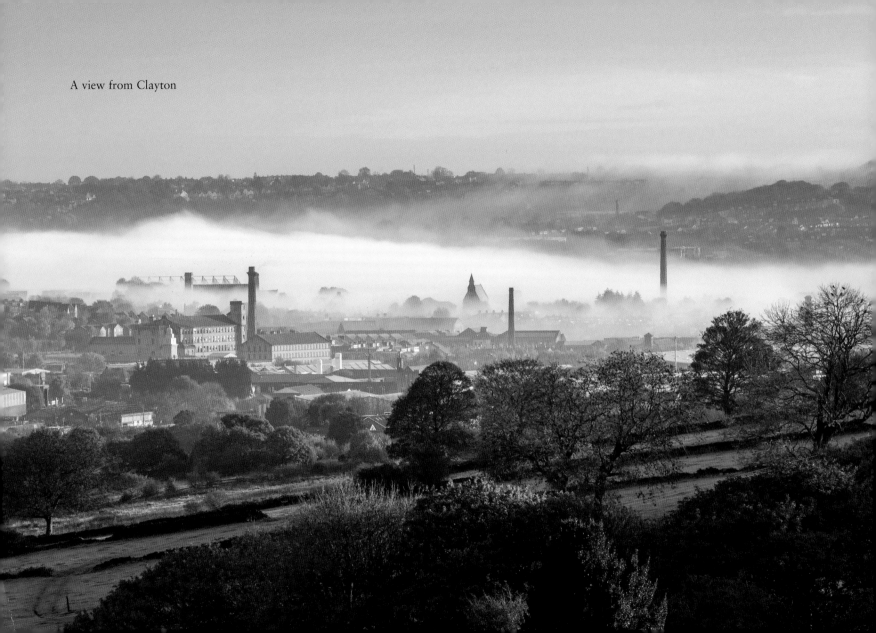
A view from Clayton

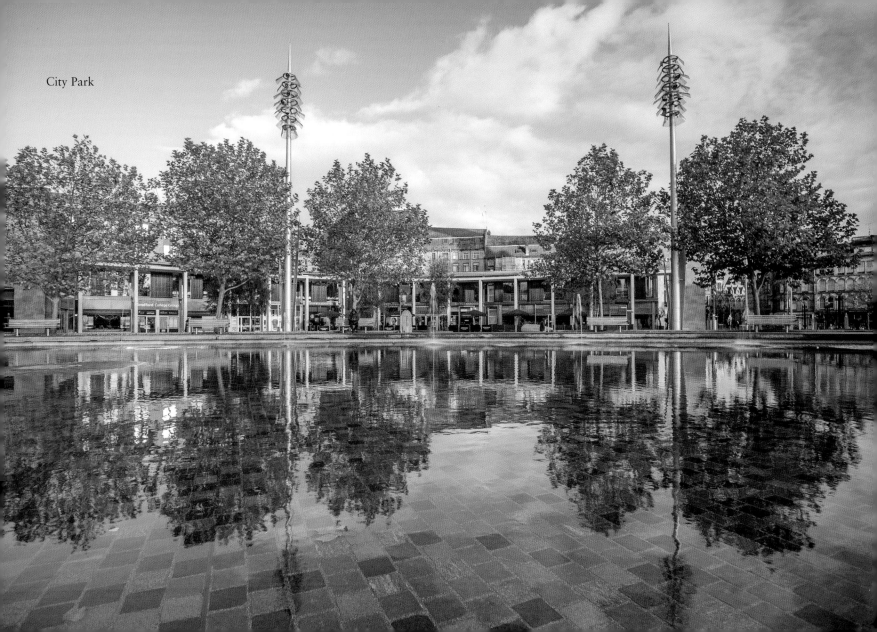

City Park

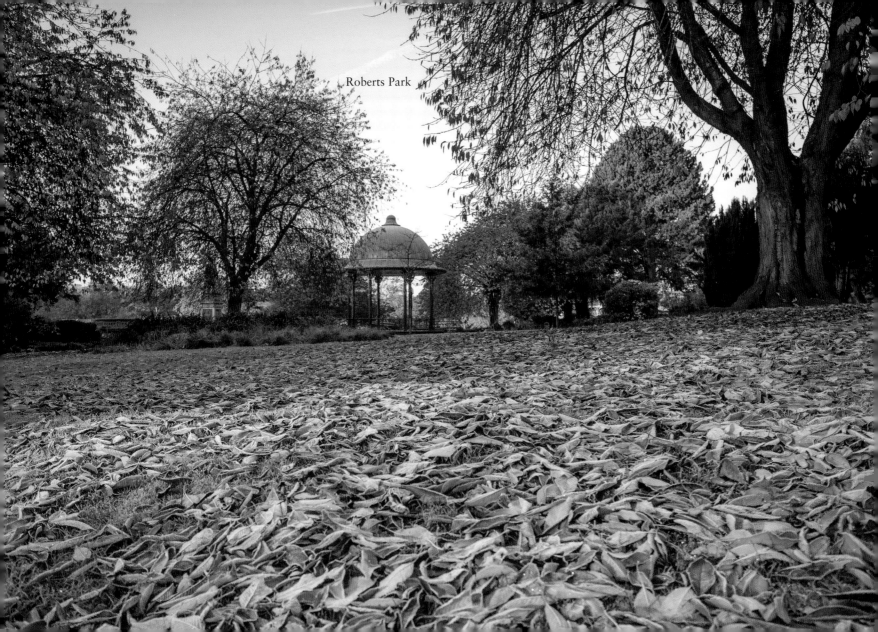
Roberts Park

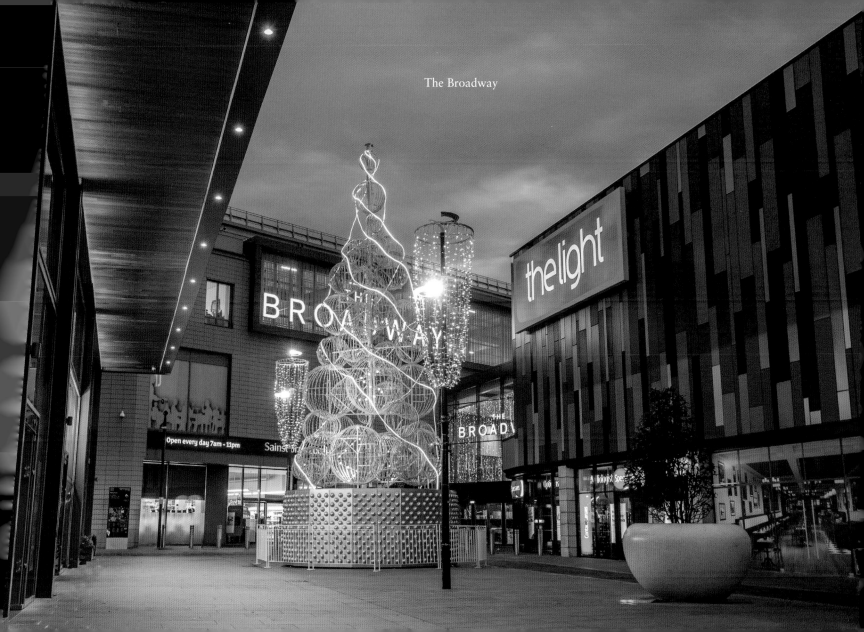

The Broadway

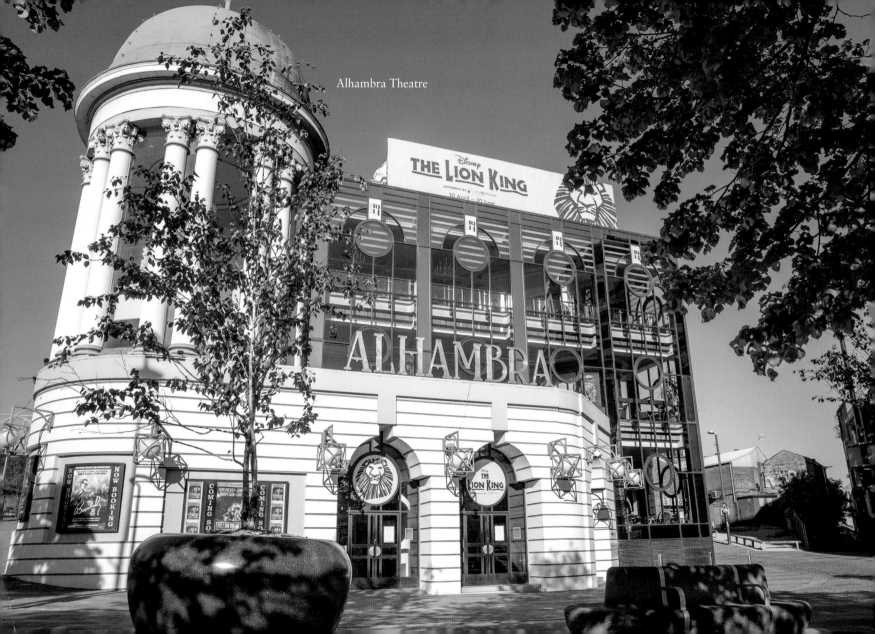

Alhambra Theatre

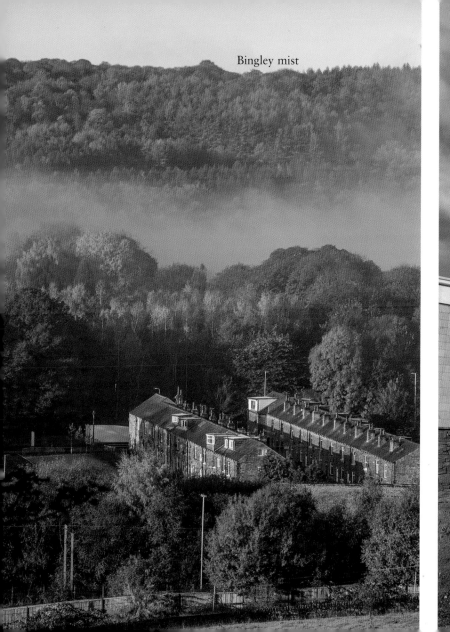

Bingley mist

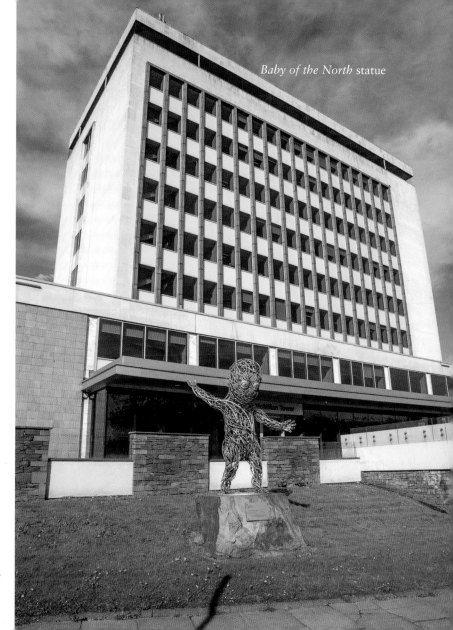

Baby of the North statue

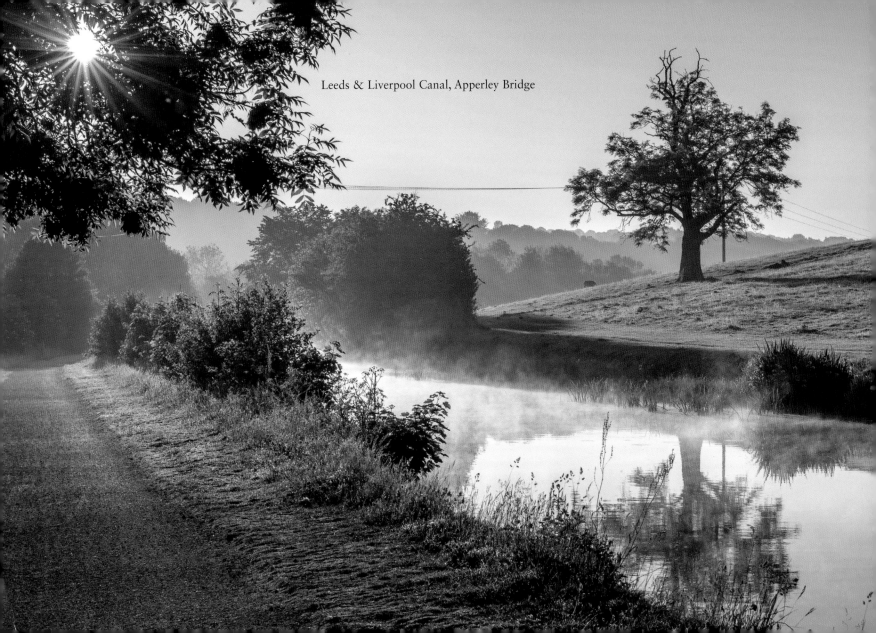

Leeds & Liverpool Canal, Apperley Bridge

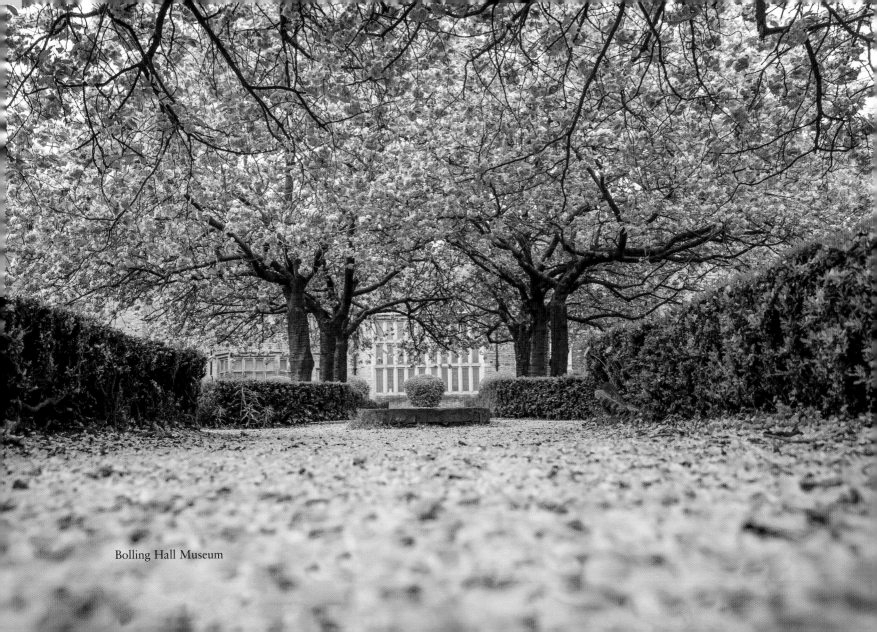

Bolling Hall Museum

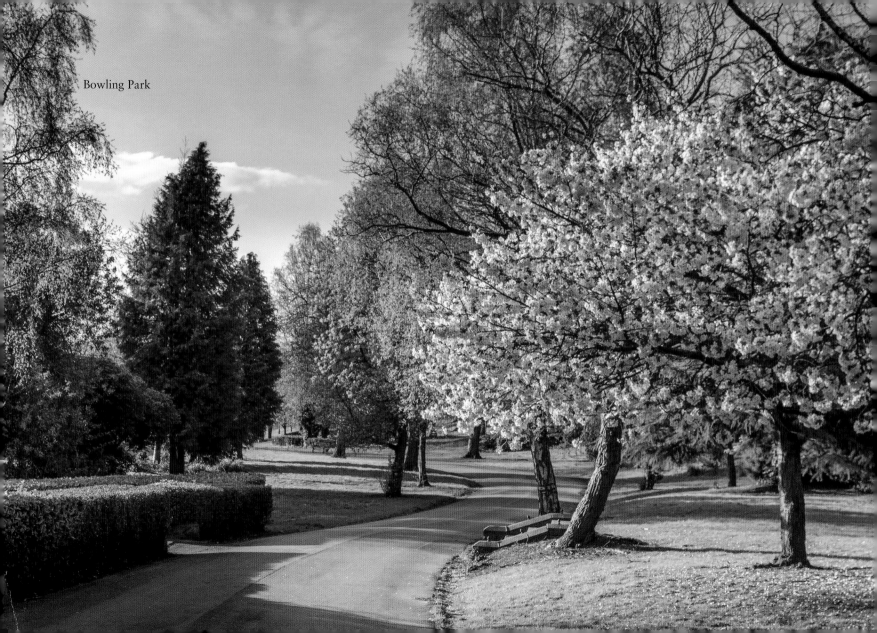
Bowling Park

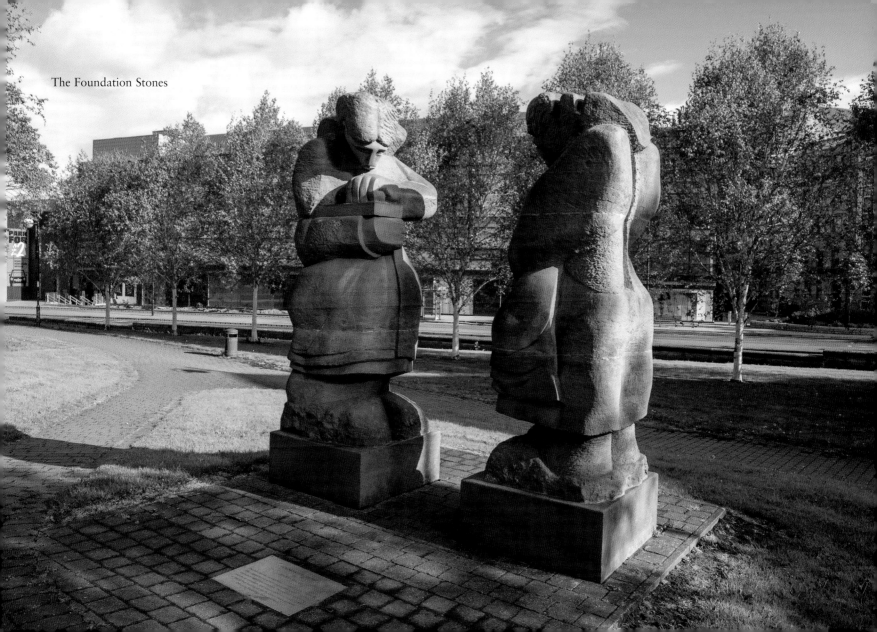

The Foundation Stones

Bridge Street

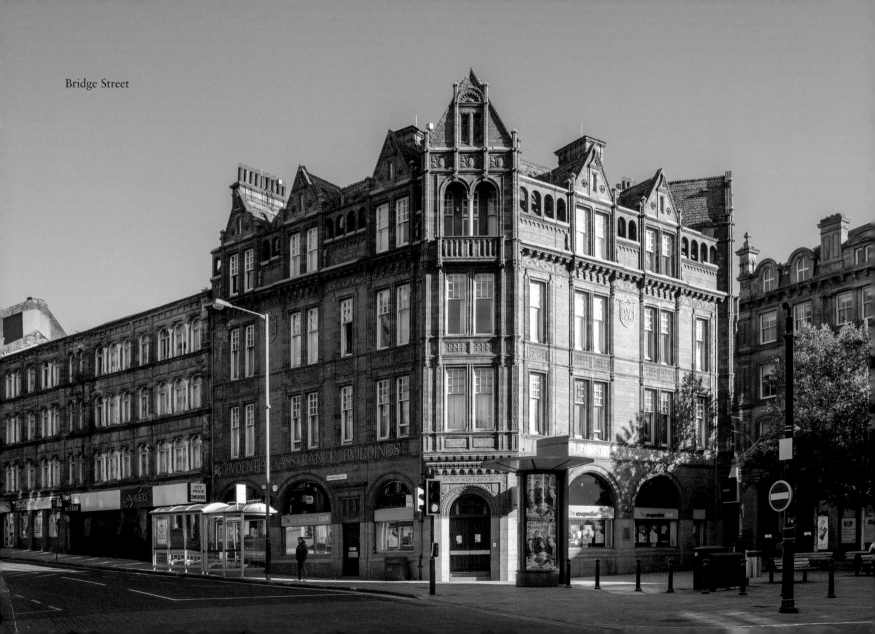

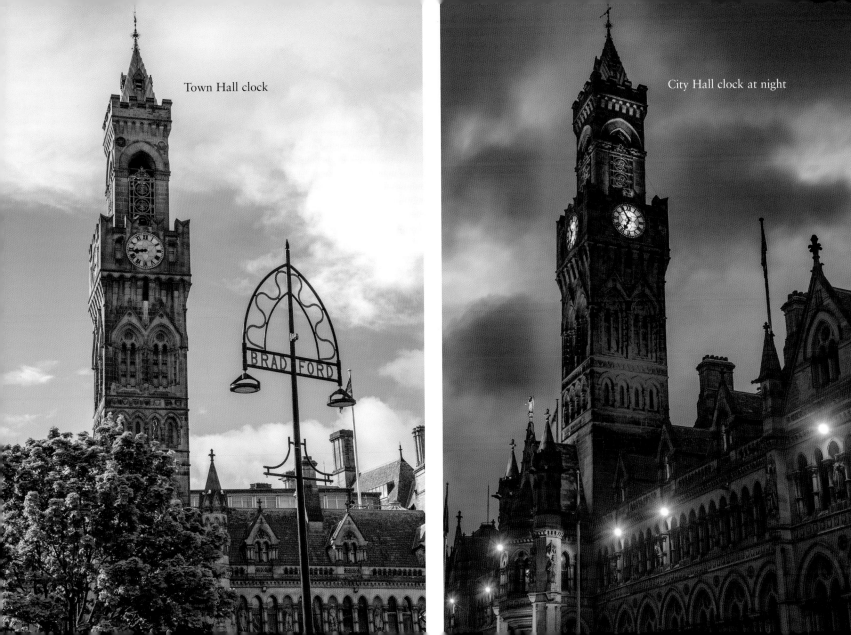

Town Hall clock

City Hall clock at night

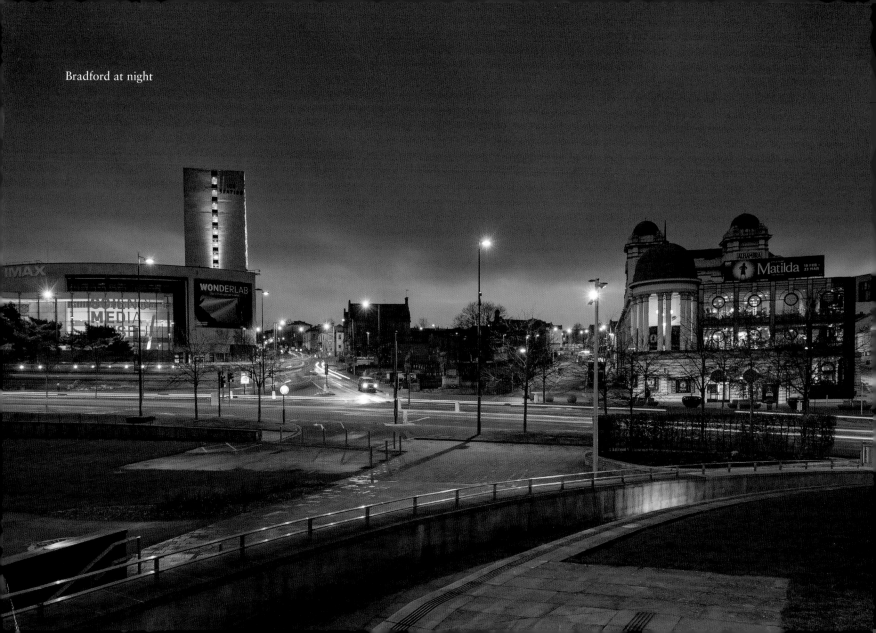

Bradford at night

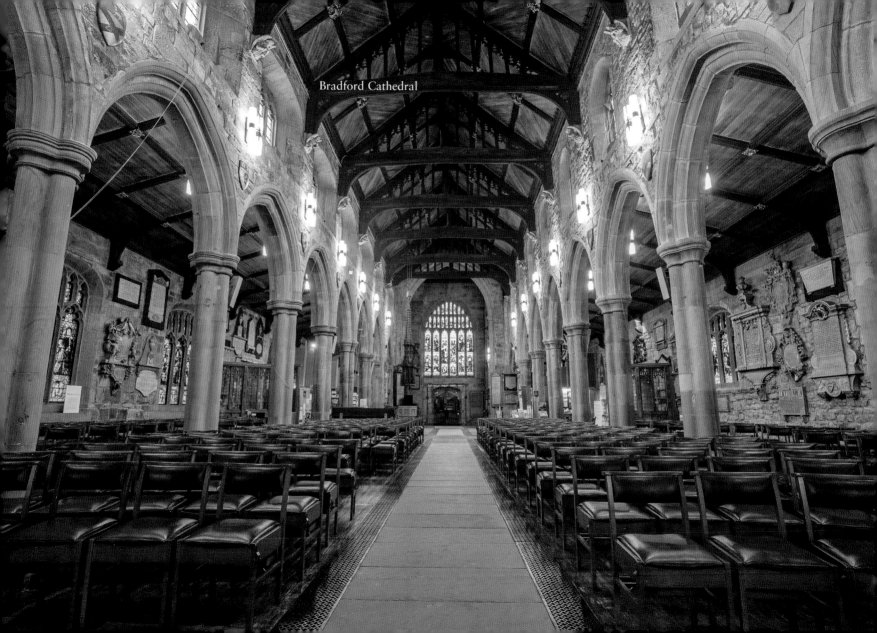

Bradford Cathedral

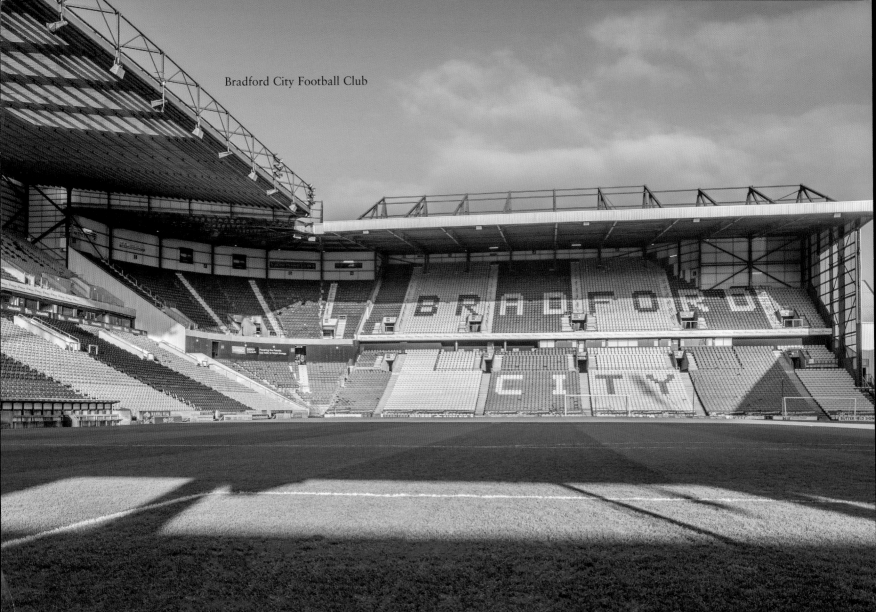

Bradford City Football Club

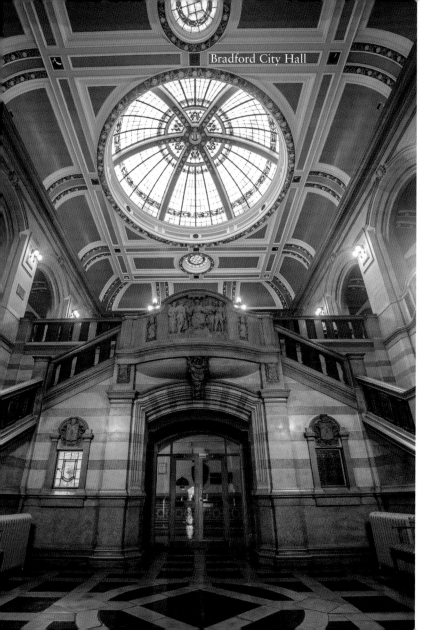
Bradford City Hall

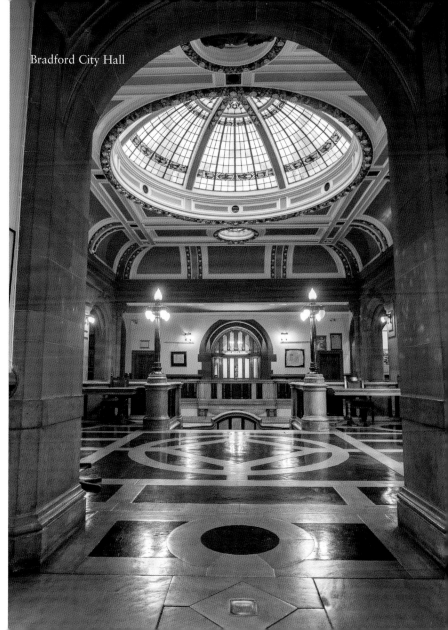
Bradford City Hall

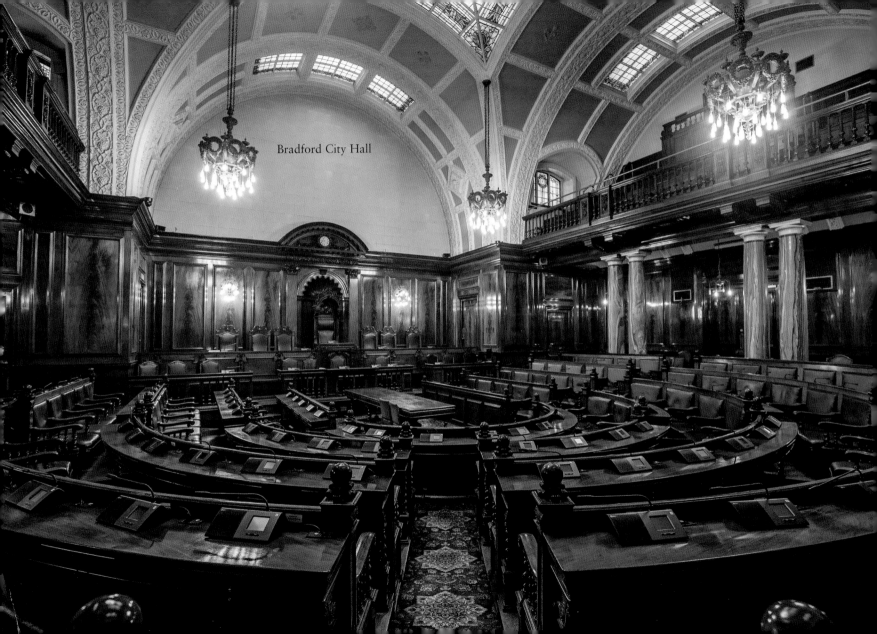

Bradford City Hall

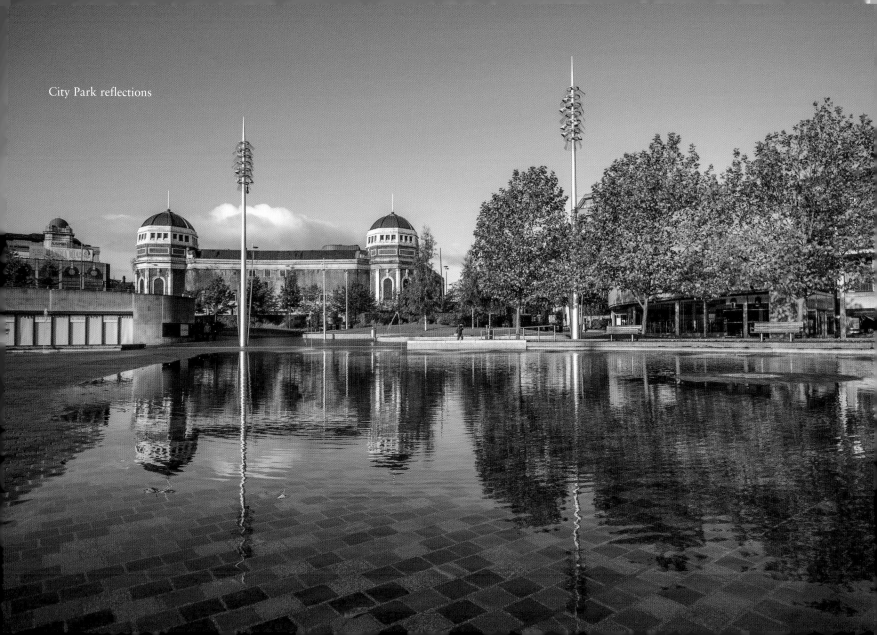

City Park reflections

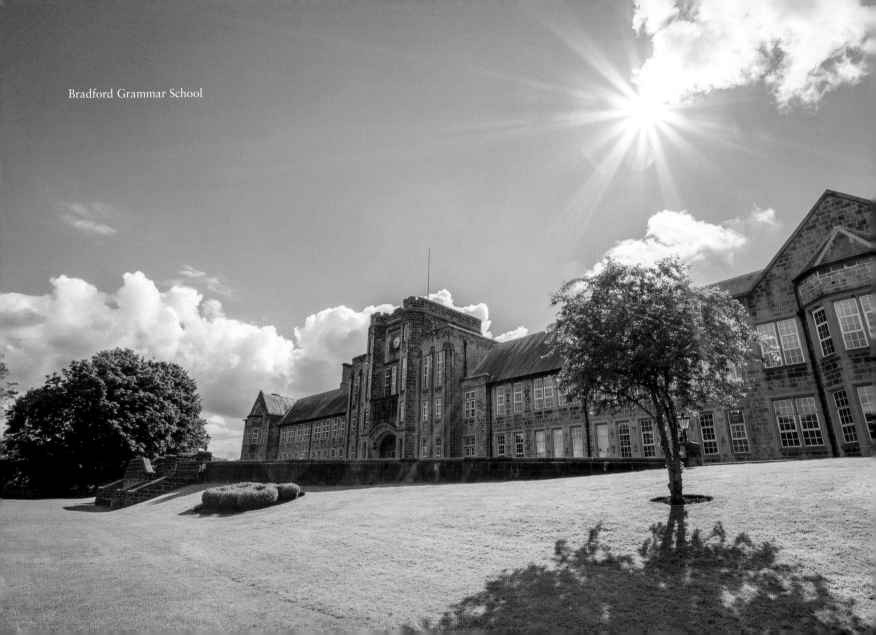

Bradford Grammar School

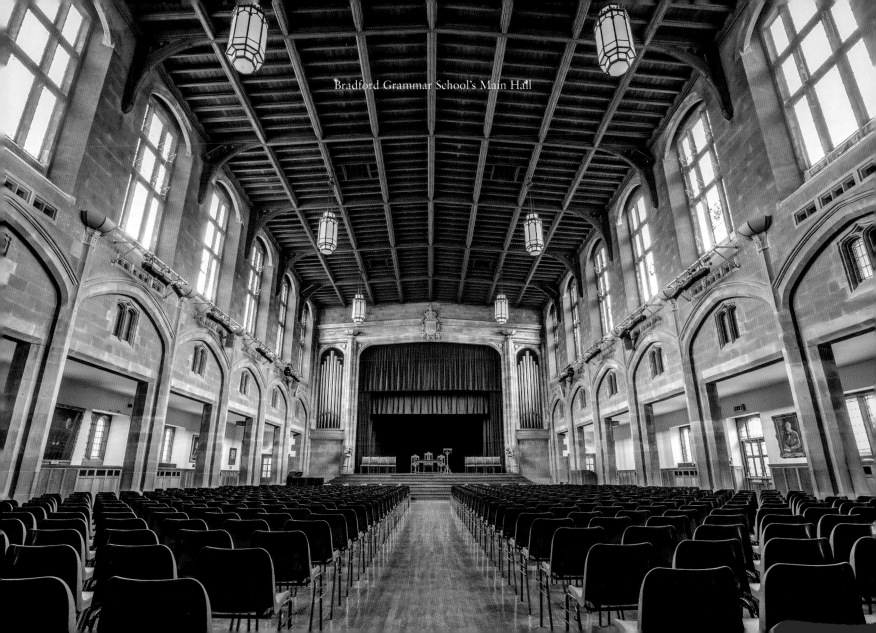

Bradford Grammar School's Main Hall

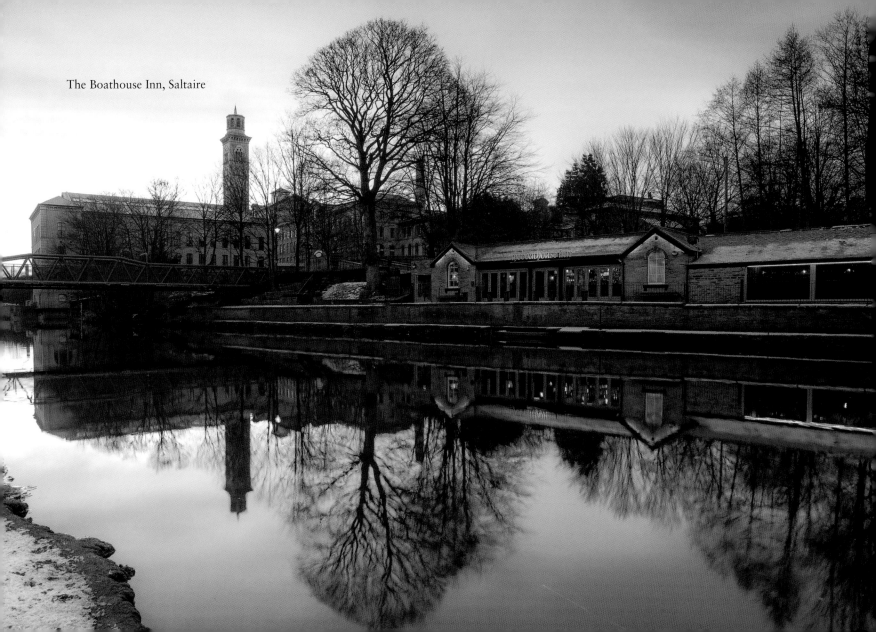

The Boathouse Inn, Saltaire

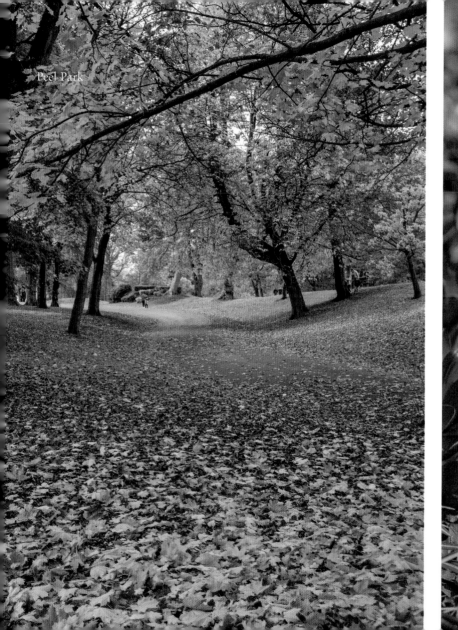

Peel Park

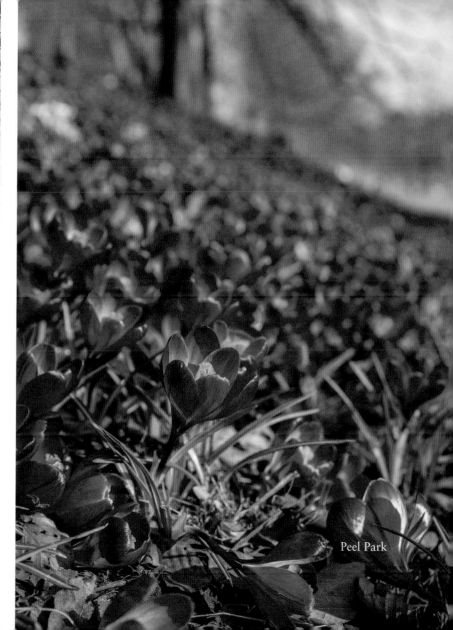

Peel Park

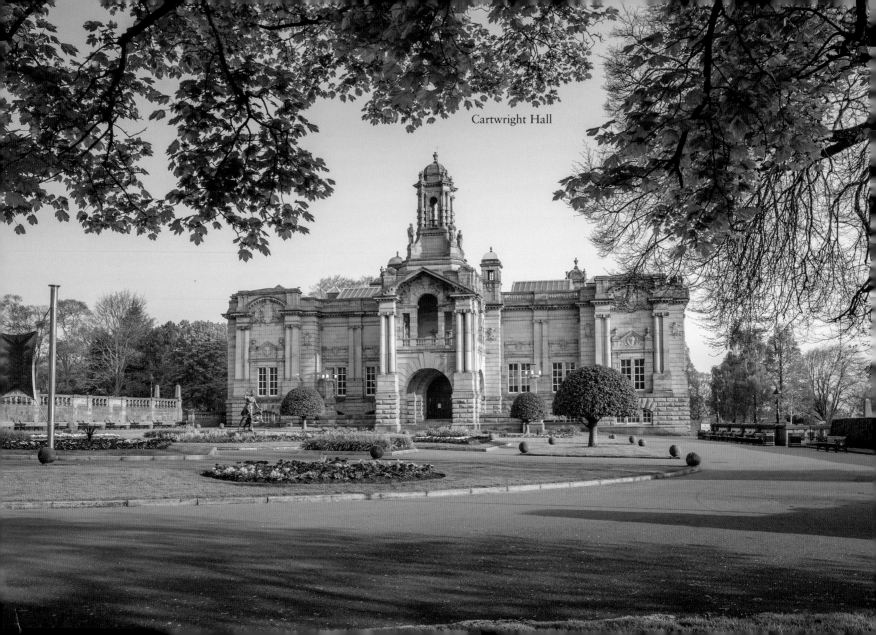

Cartwright Hall

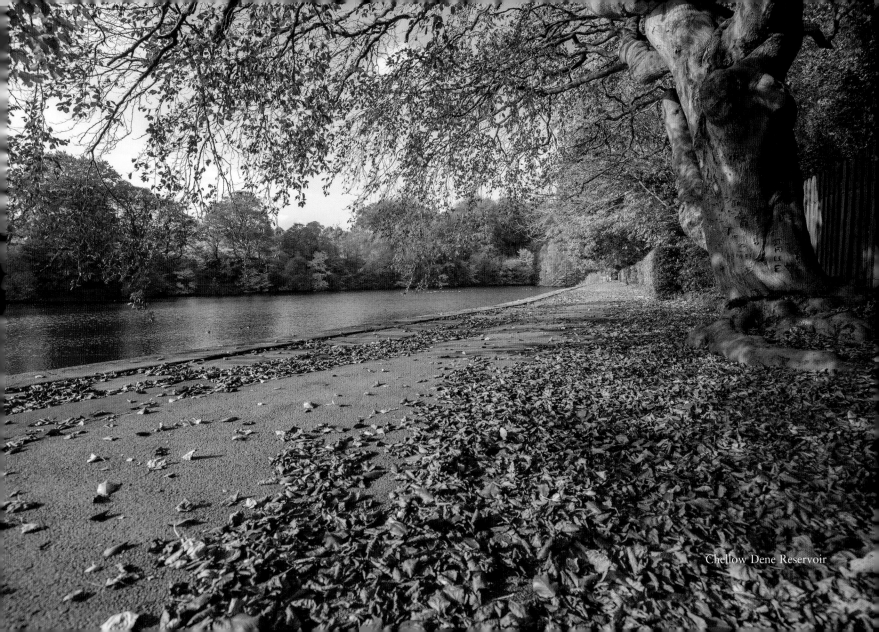

Chellow Dene Reservoir

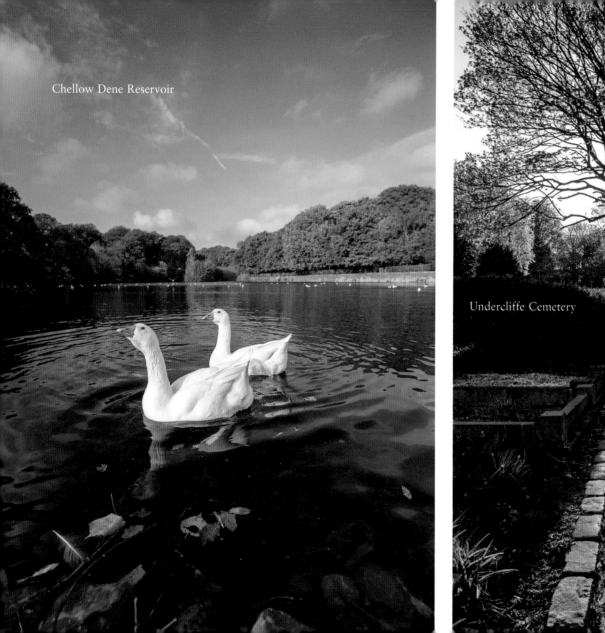

Chellow Dene Reservoir

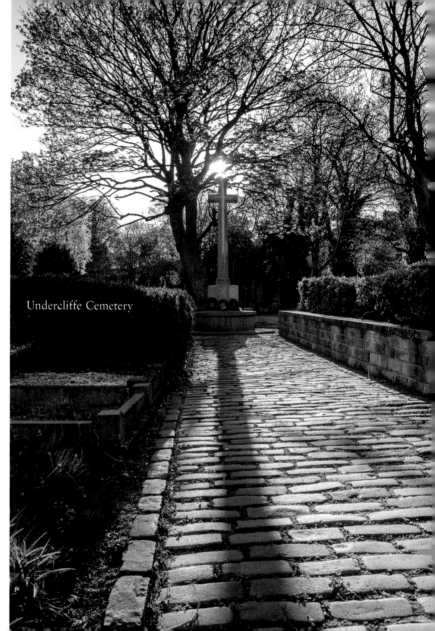

Undercliffe Cemetery

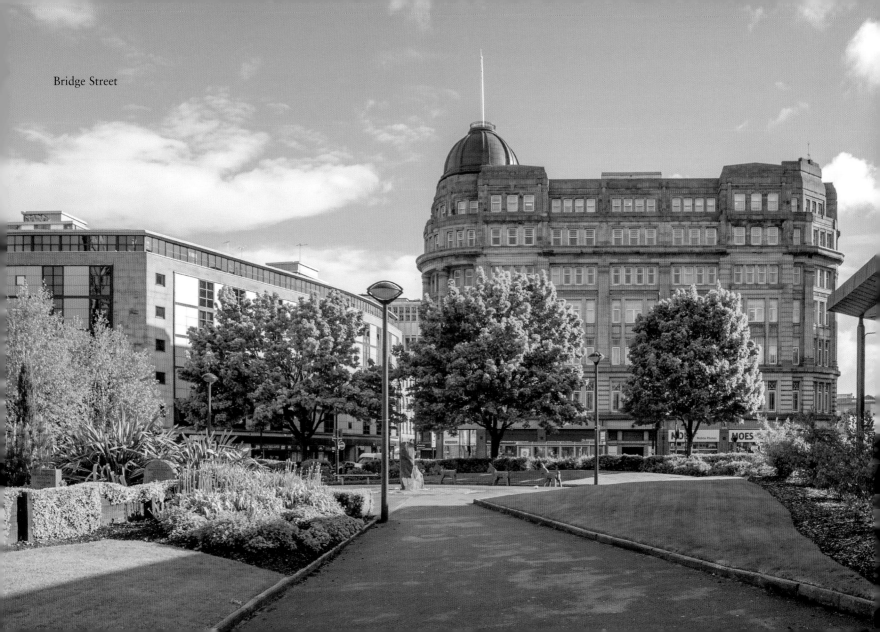

Bridge Street

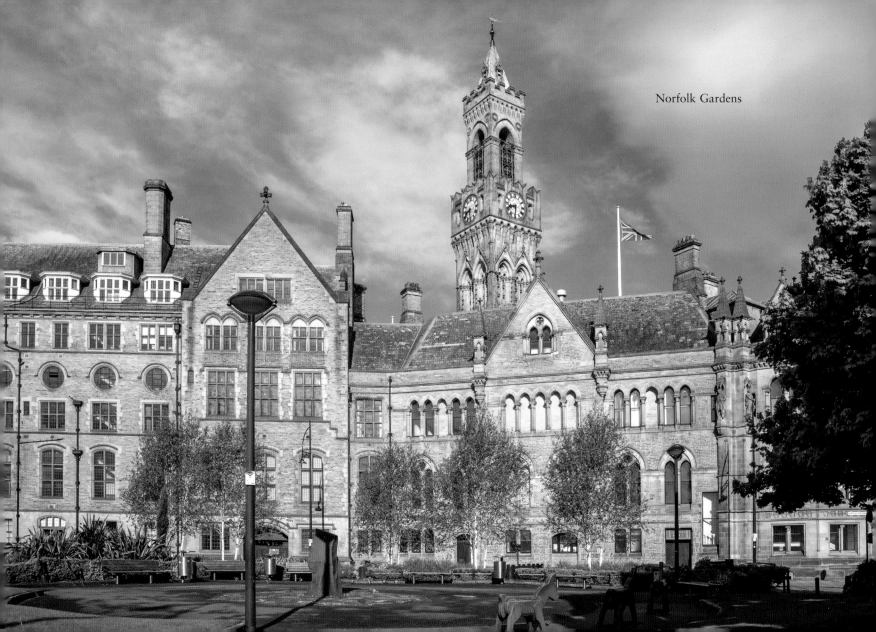
Norfolk Gardens

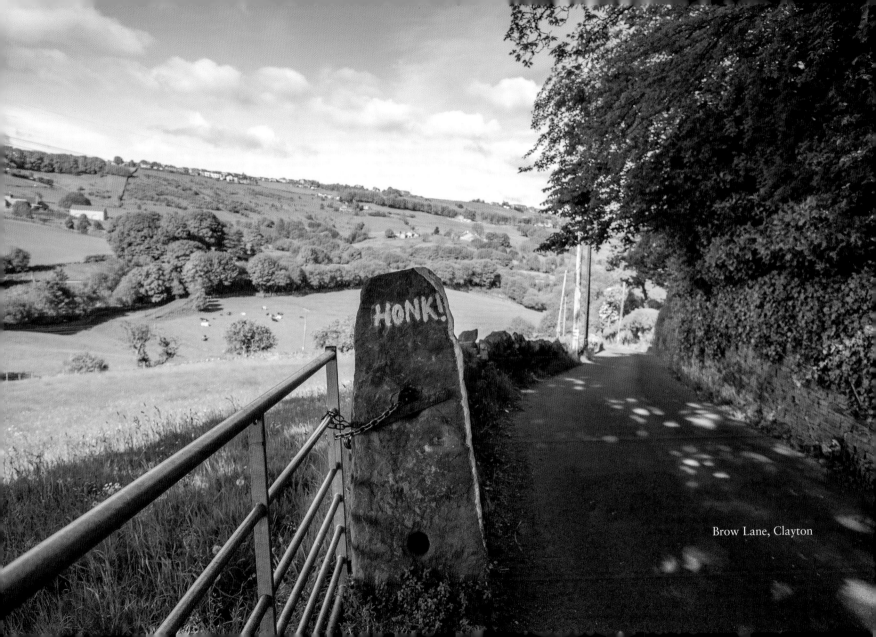

Brow Lane, Clayton

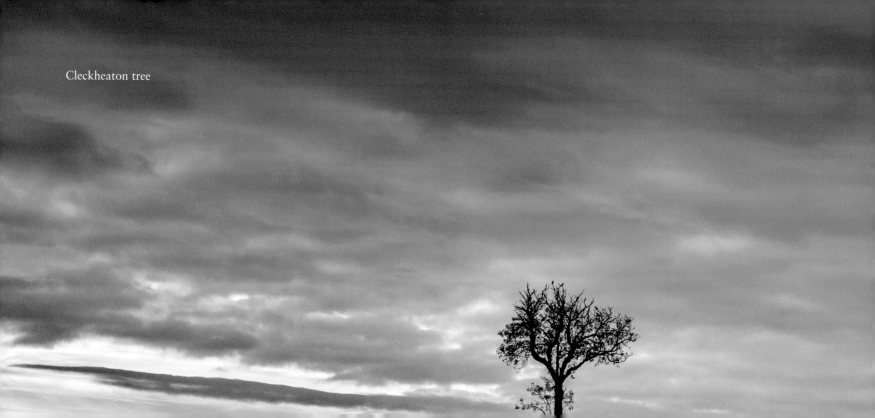

Cleckheaton tree

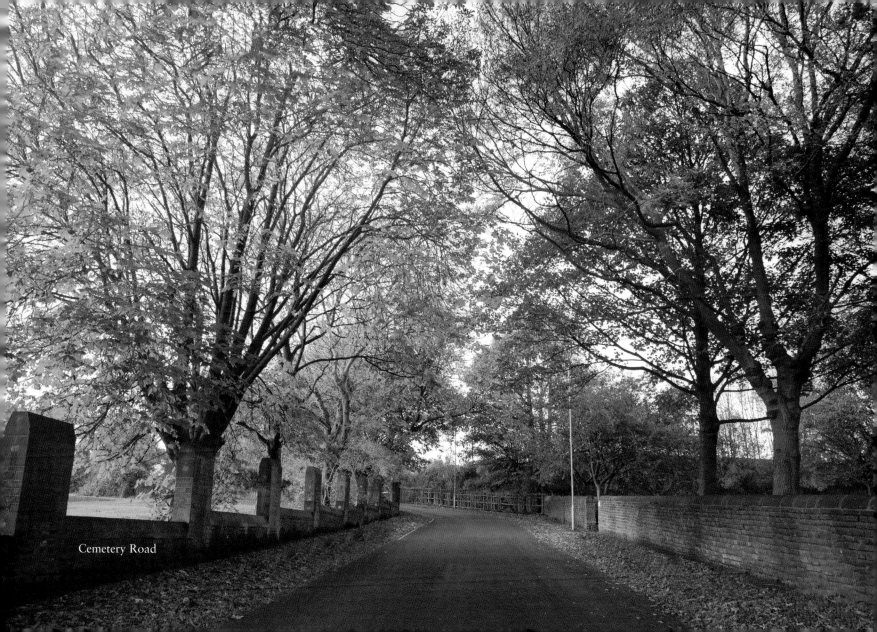

Cemetery Road

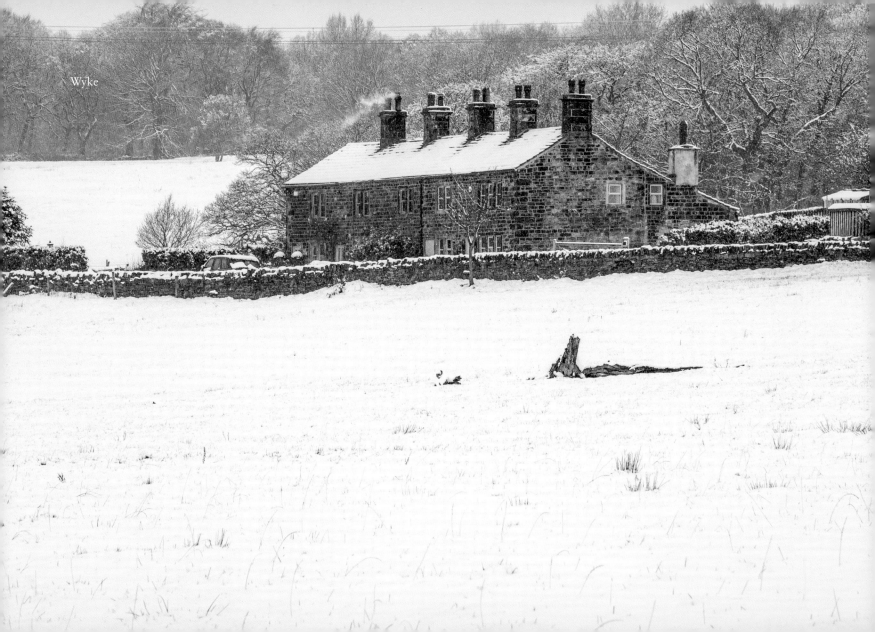

Wyke

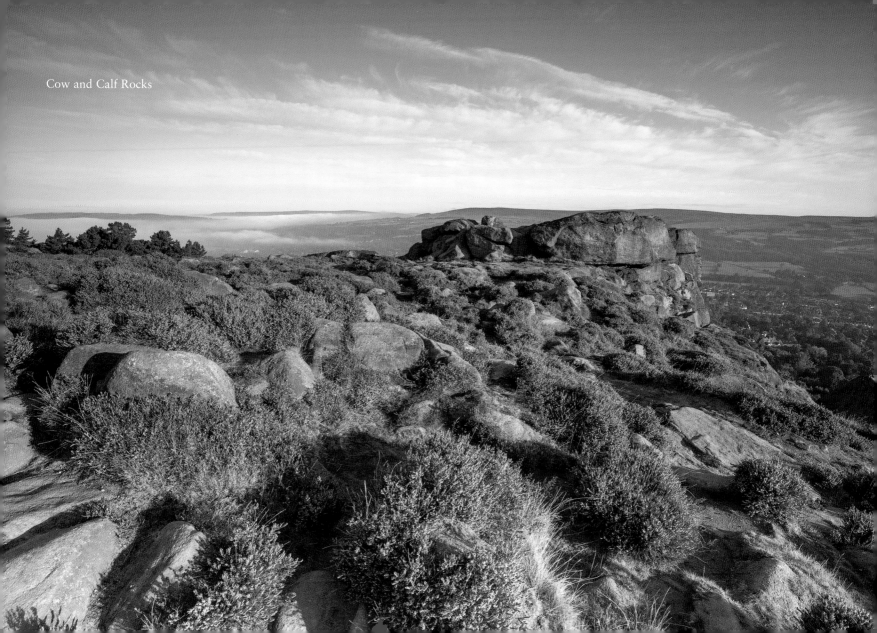

Cow and Calf Rocks

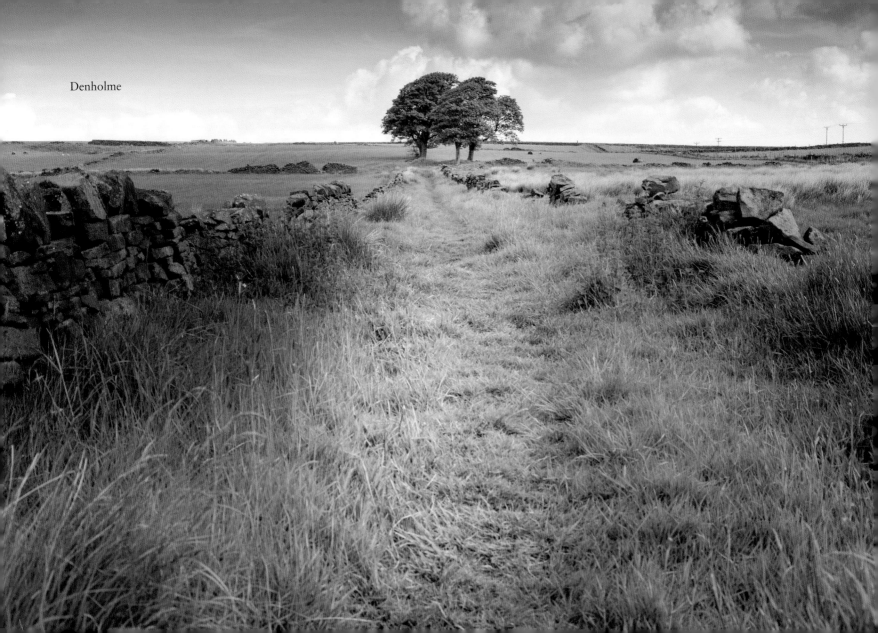

Denholme

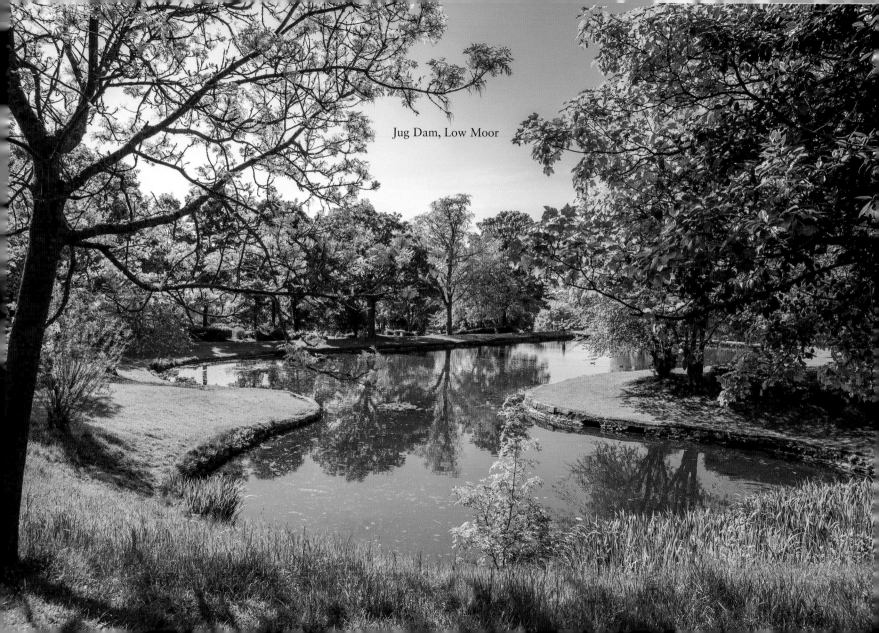

Jug Dam, Low Moor

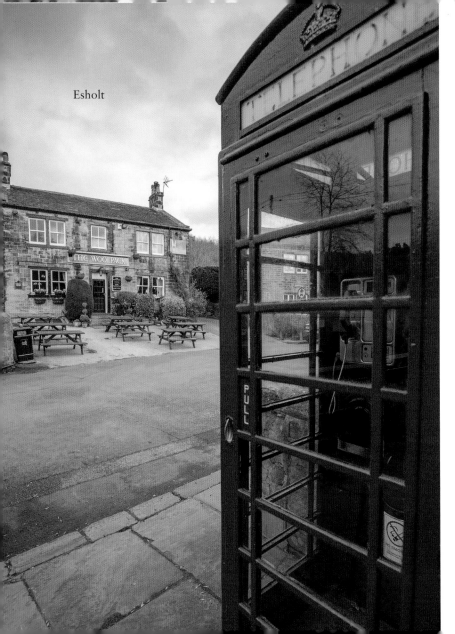

Esholt

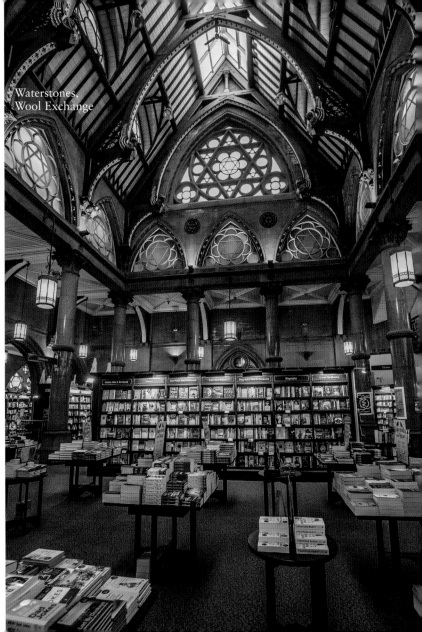

Waterstones,
Wool Exchange

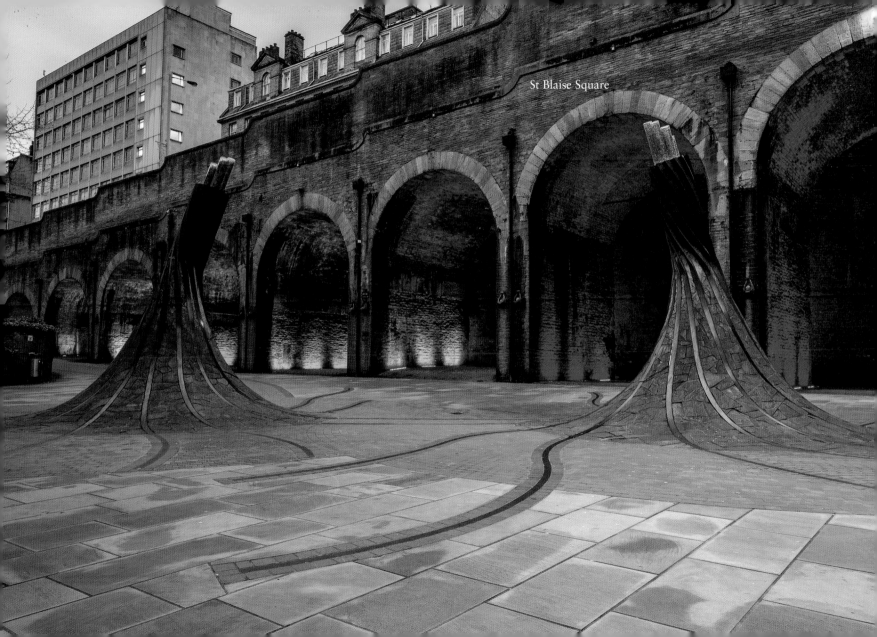

St Blaise Square

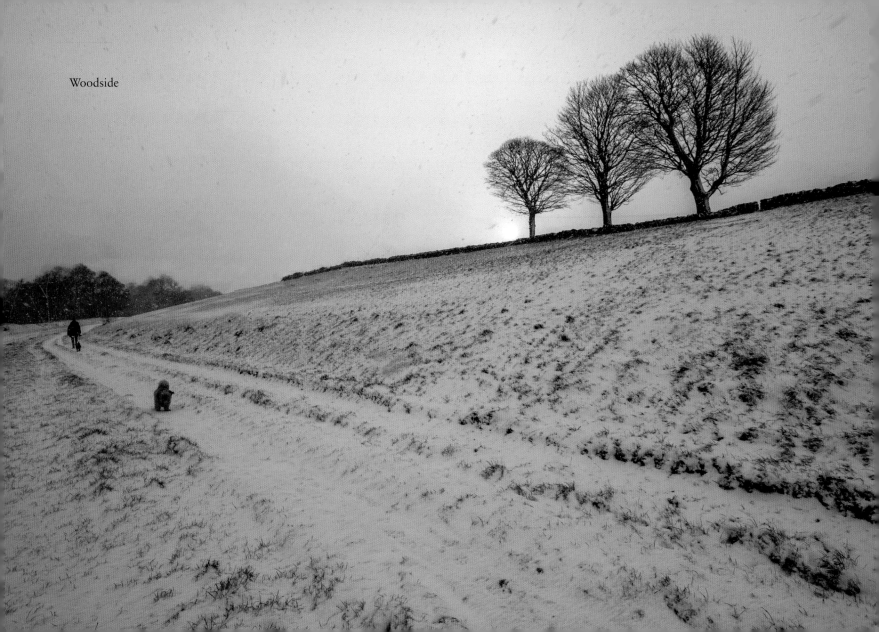

Woodside

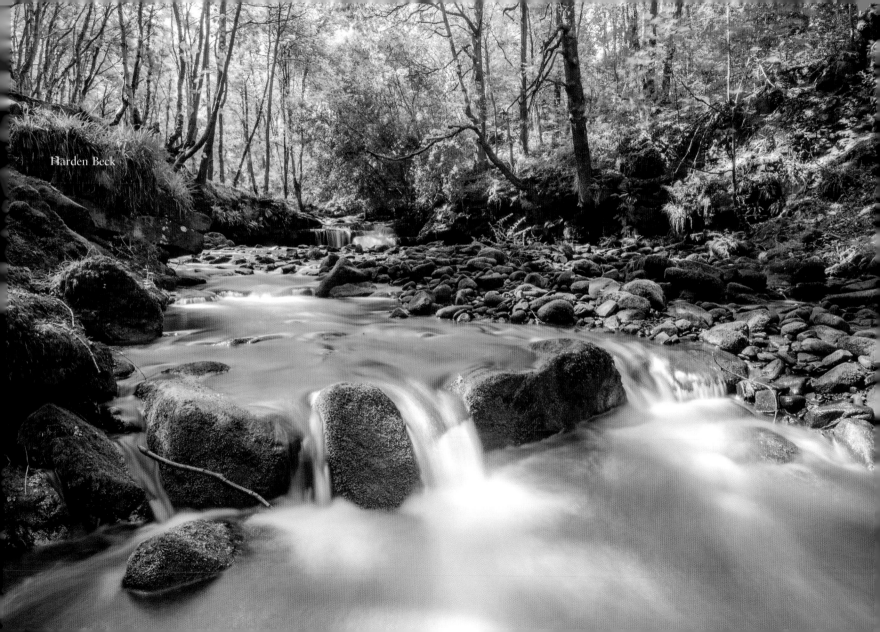

Harden Beck

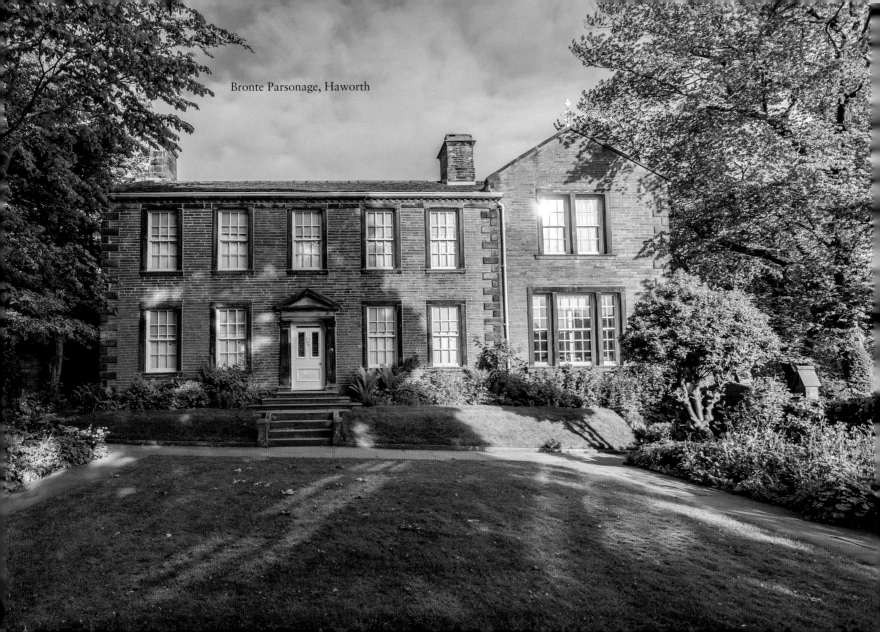

Bronte Parsonage, Haworth

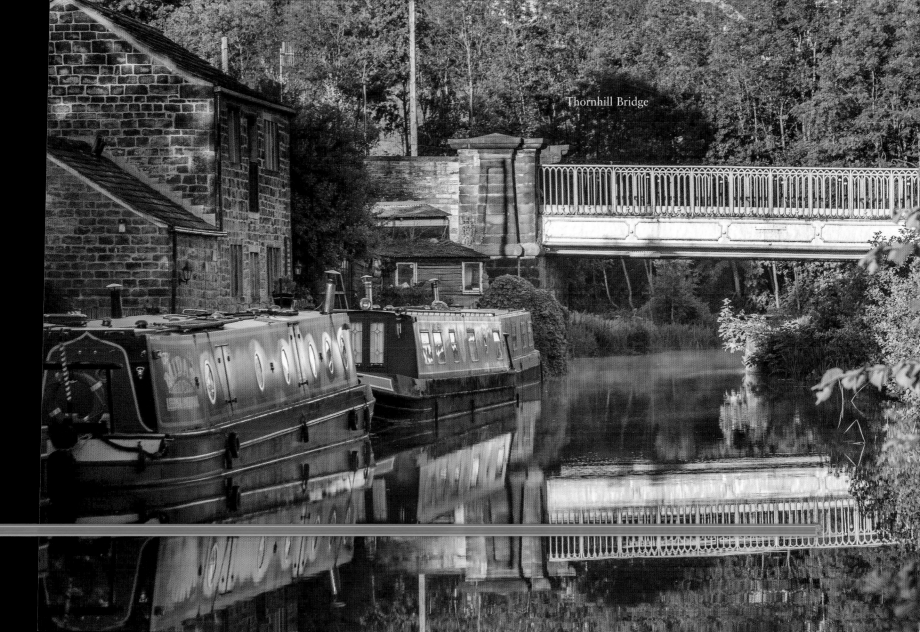

Thornhill Bridge

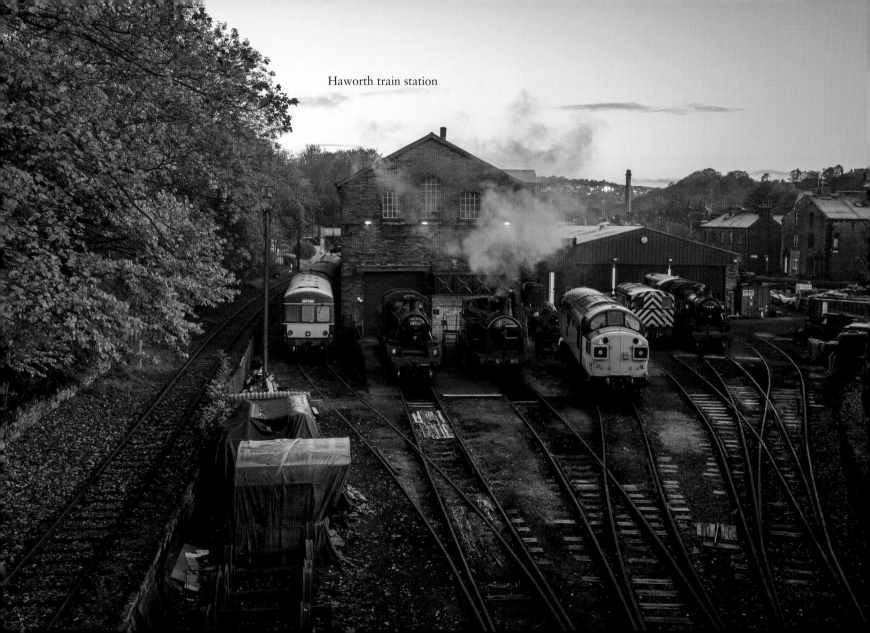

Haworth train station

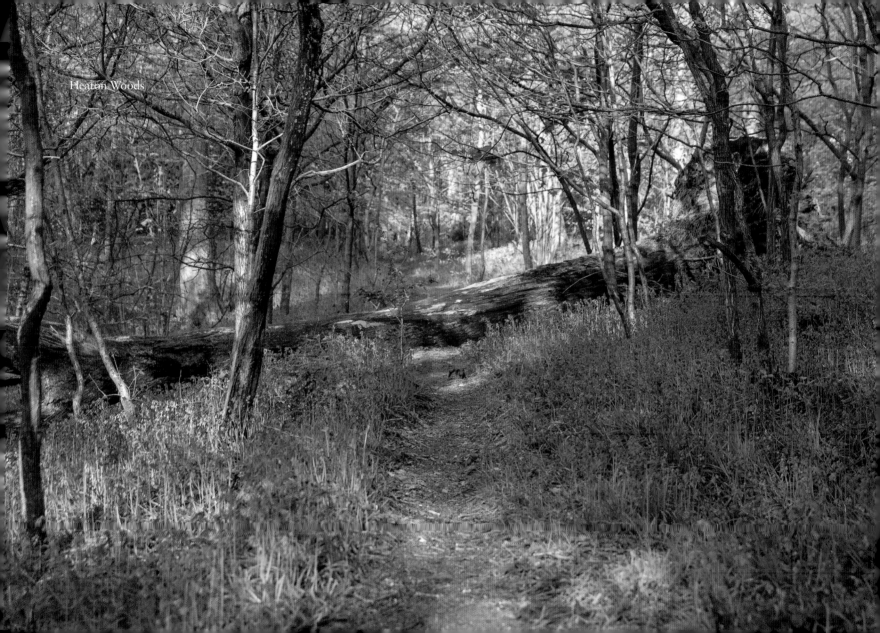

Heaton Woods

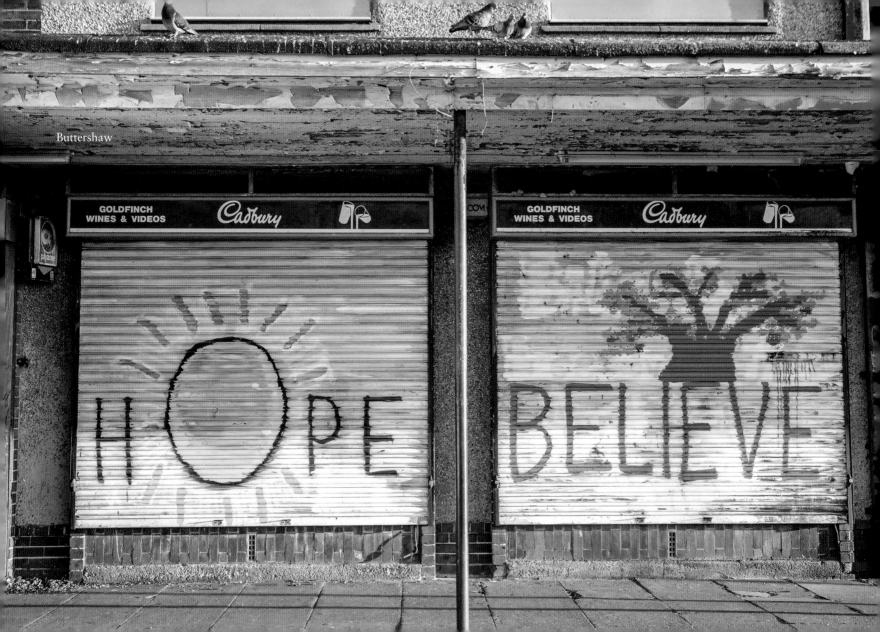

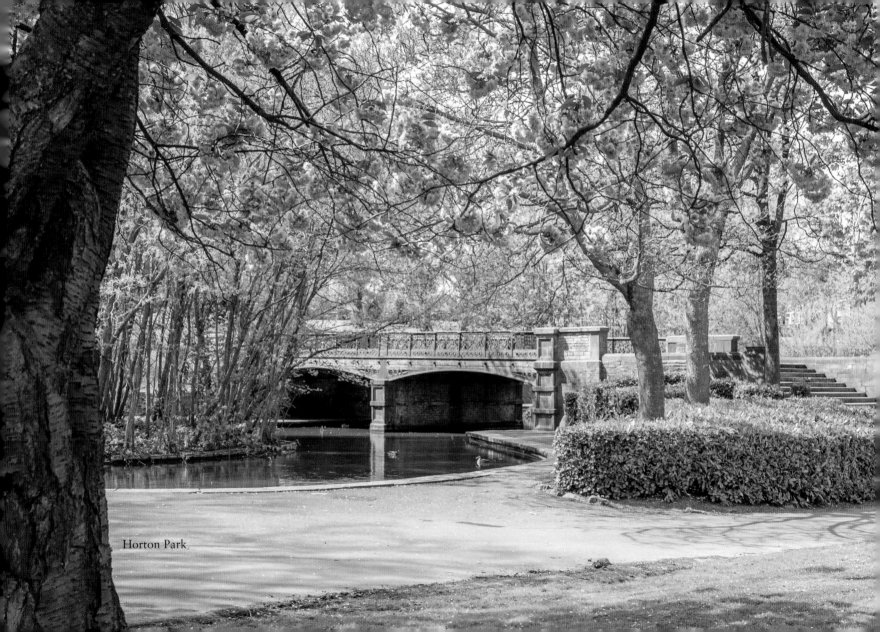

Horton Park

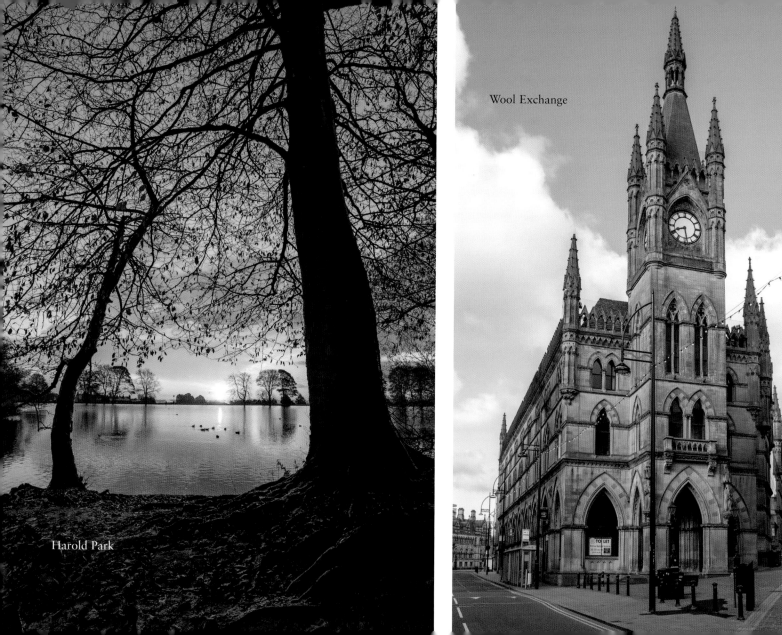

Harold Park

Wool Exchange

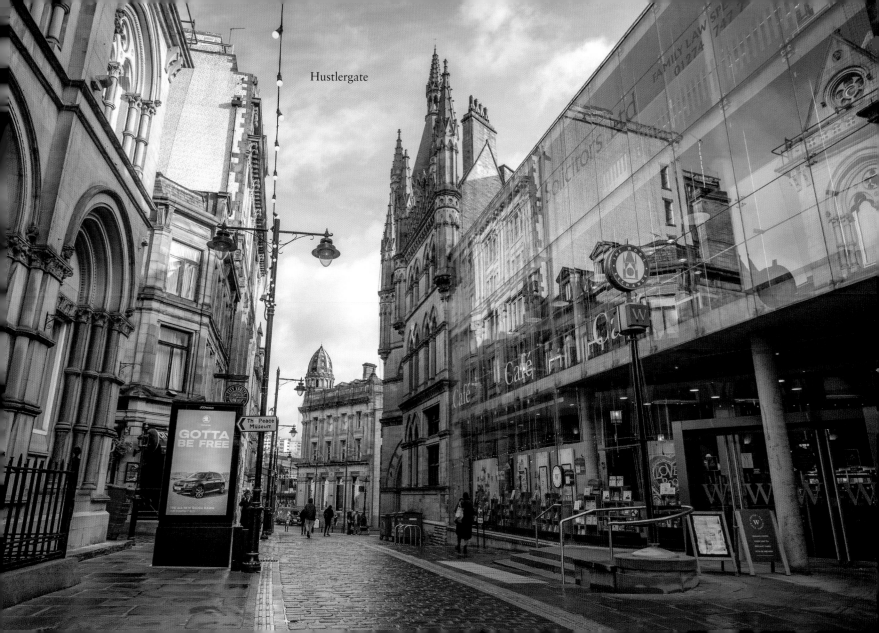

Hustlergate

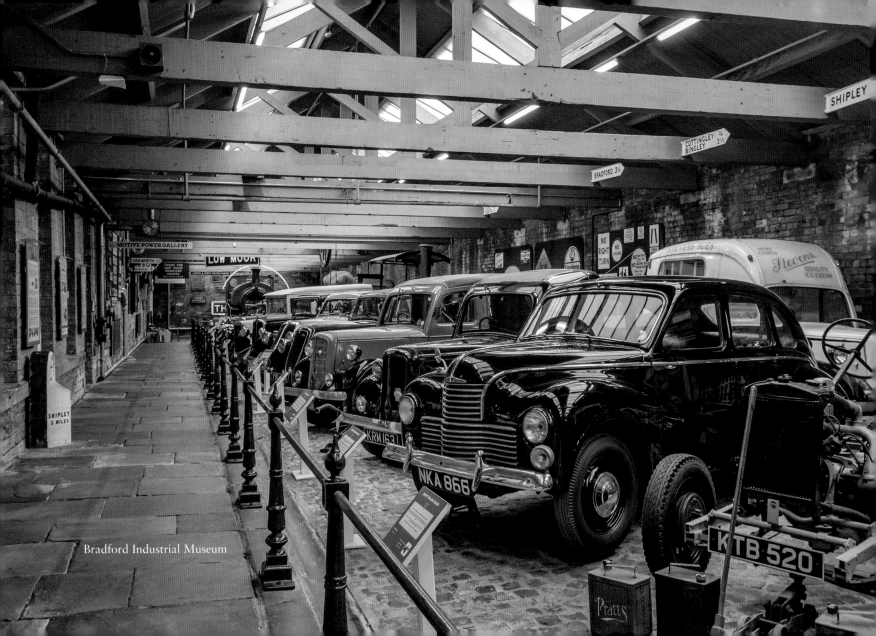

Bradford Industrial Museum

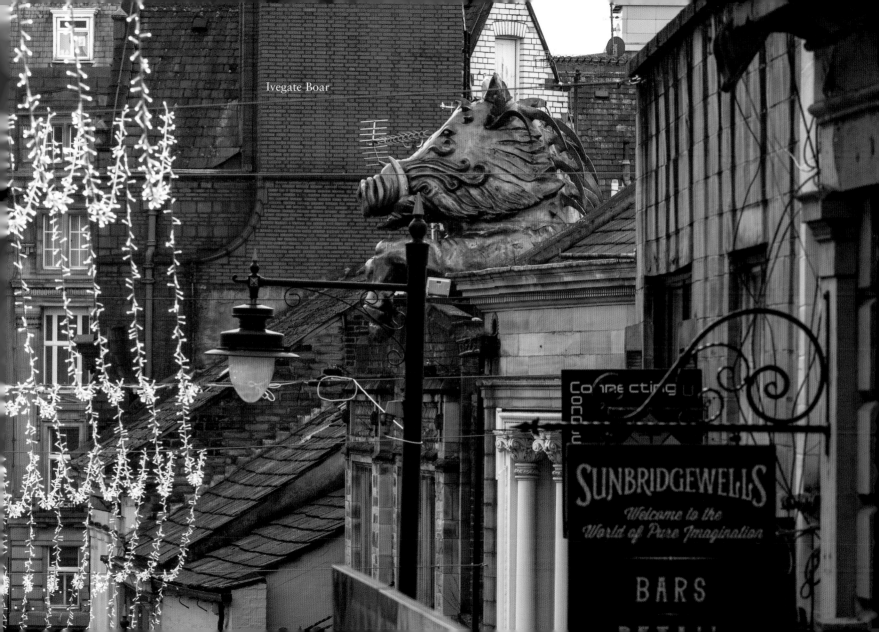

Ivegate Boar

SUNBRIDGEWELLS

Welcome to the
World of Pure Imagination

BARS

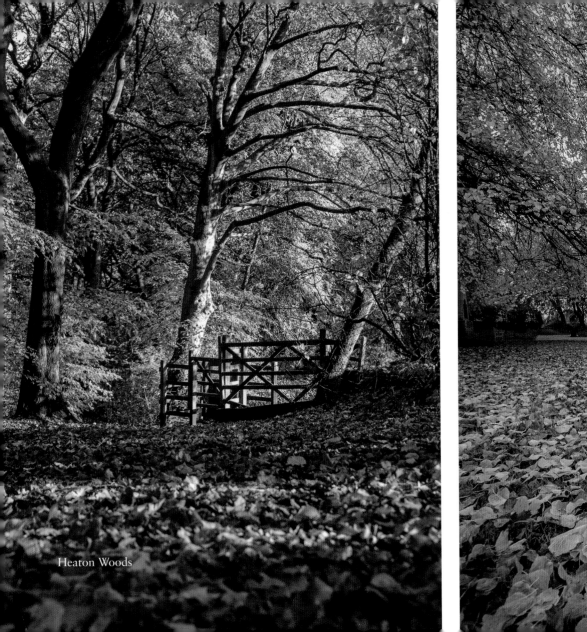

Heaton Woods

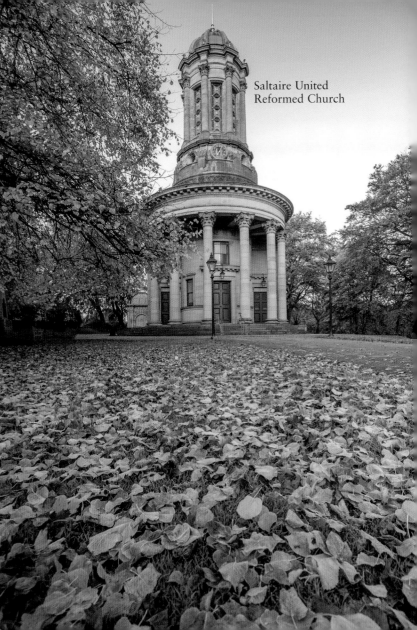

Saltaire United
Reformed Church

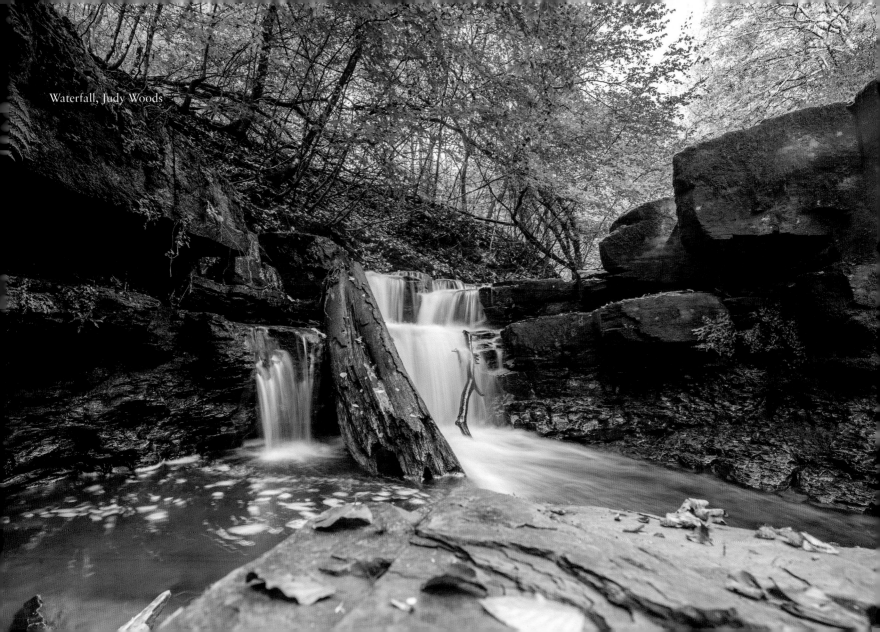

Waterfall, Judy Woods

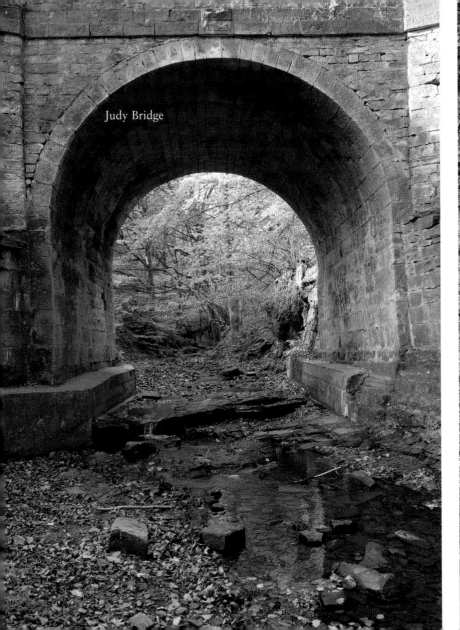

Judy Bridge

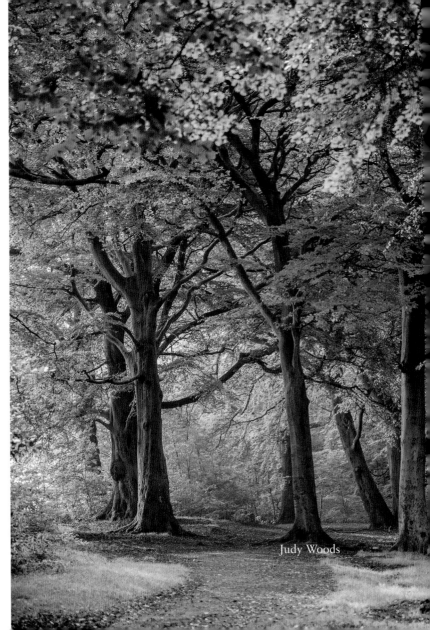

Judy Woods

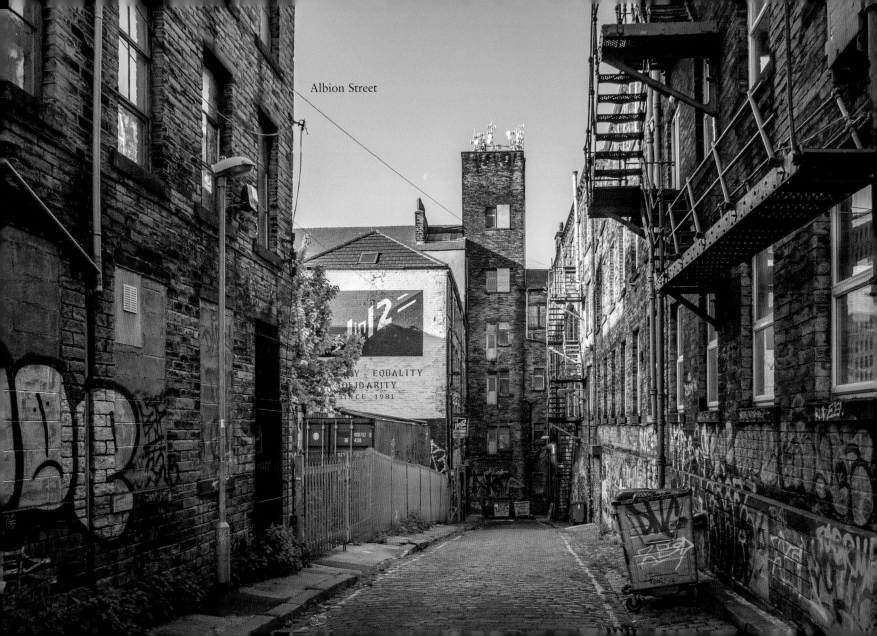

Albion Street

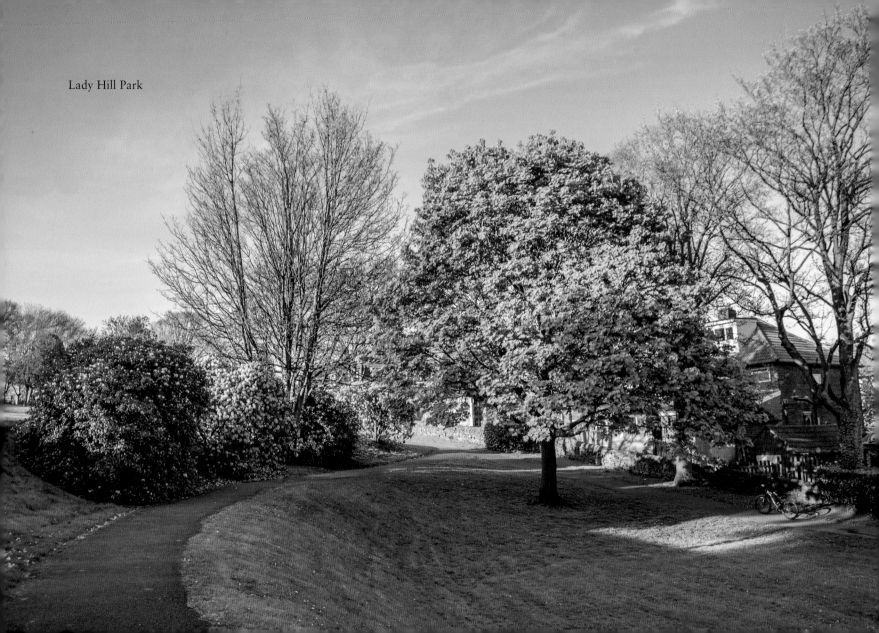

Lady Hill Park

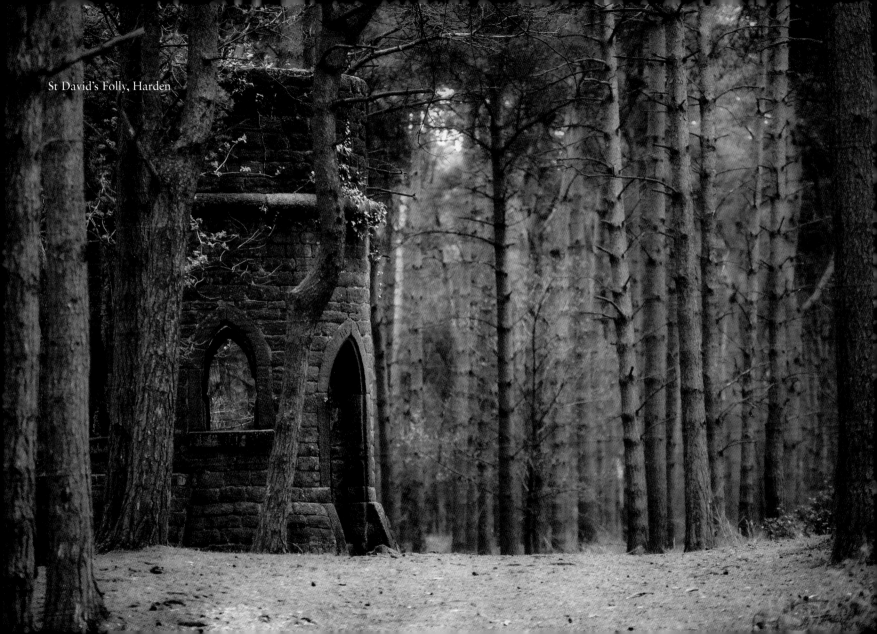

St David's Folly, Harden

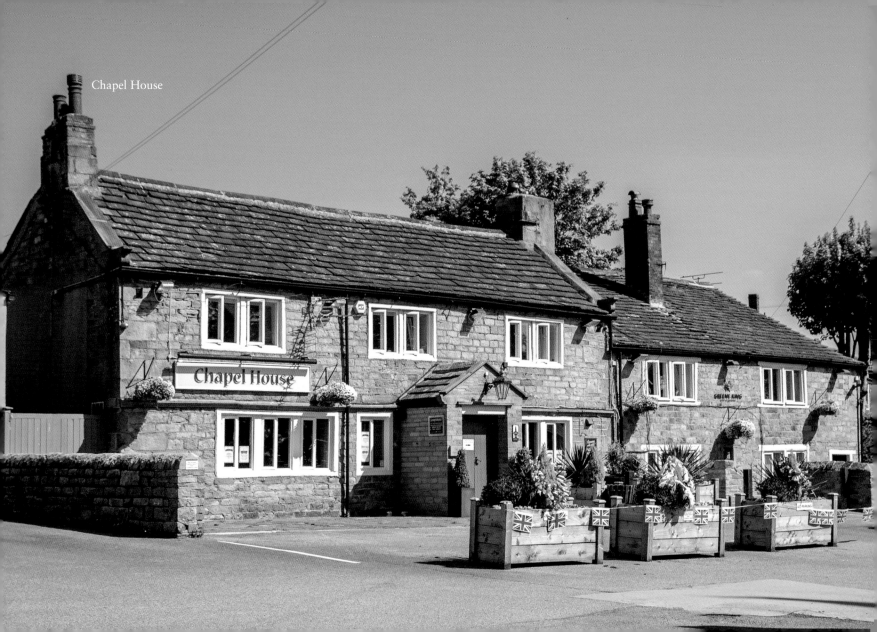
Chapel House

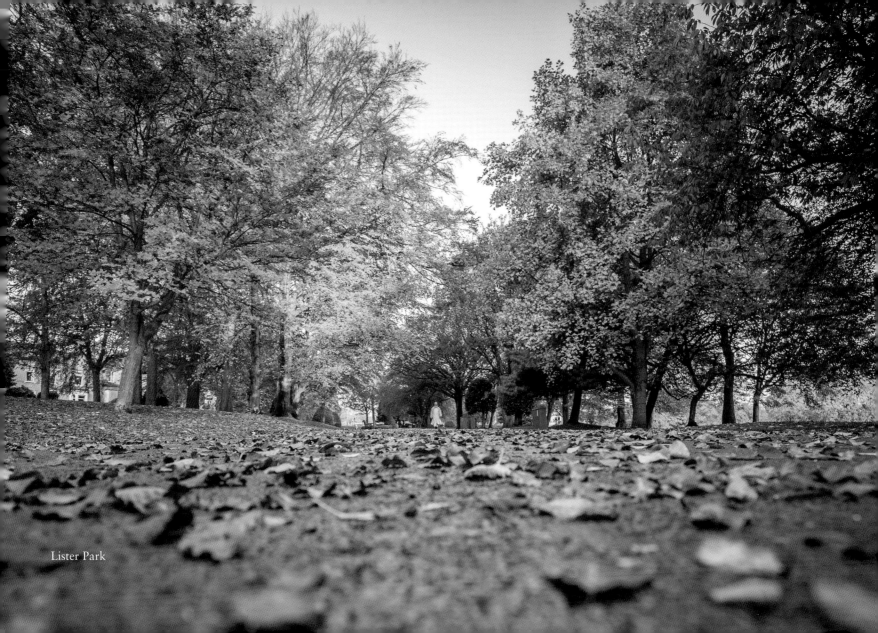

Lister Park

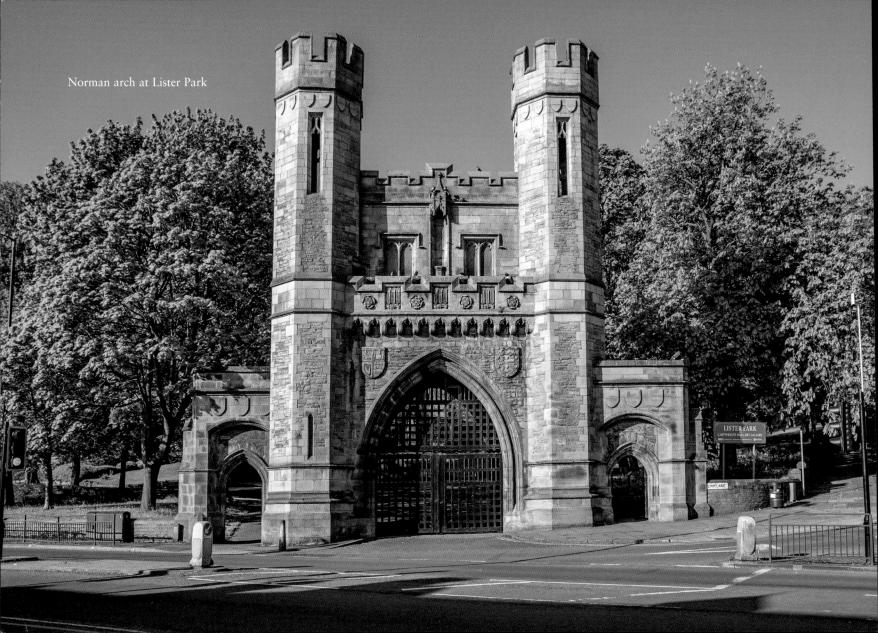

Norman arch at Lister Park

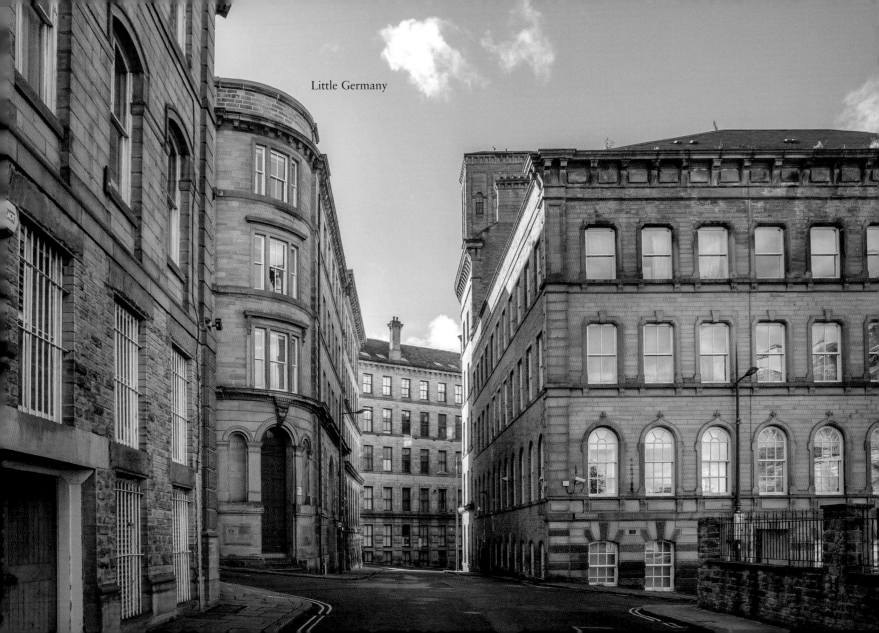

Little Germany

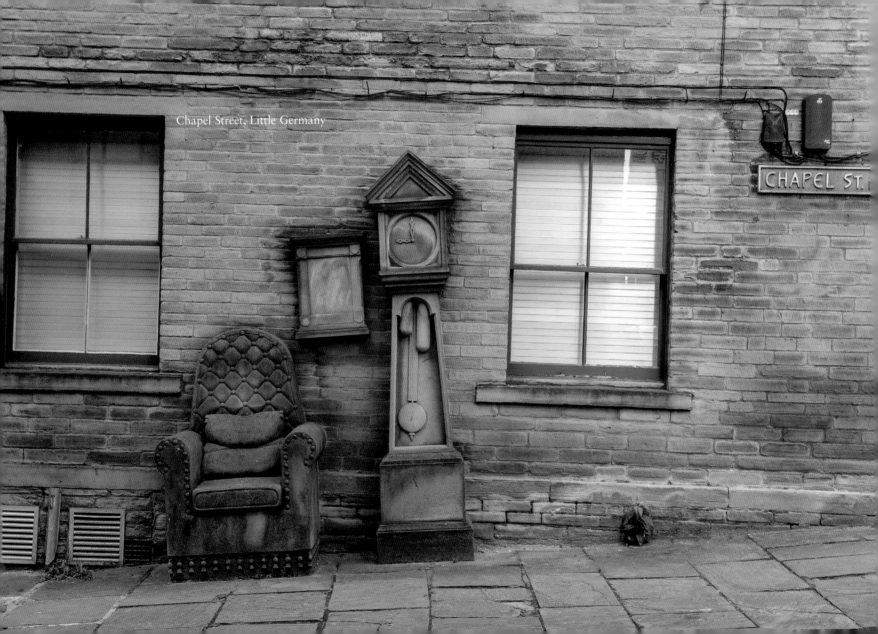
Chapel Street, Little Germany

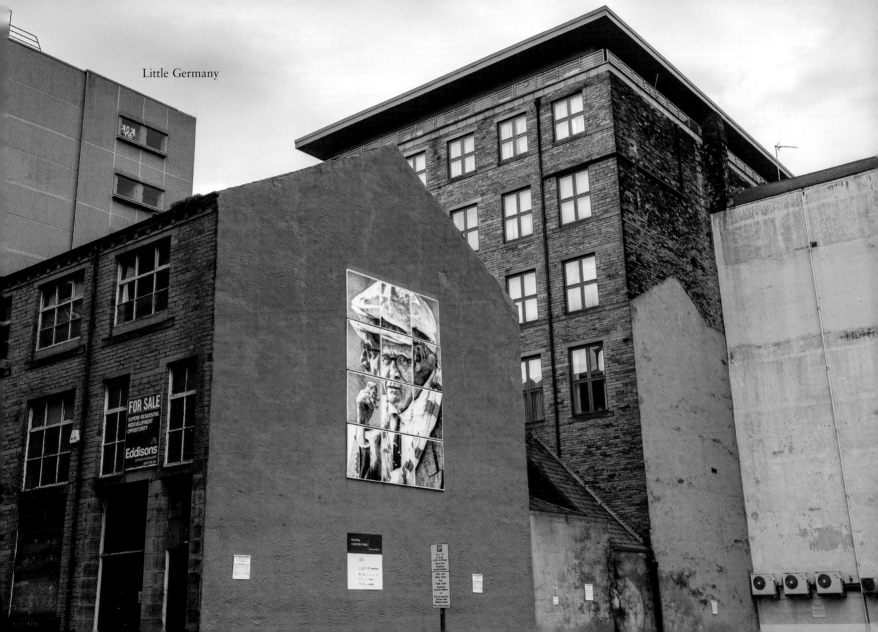

Little Germany

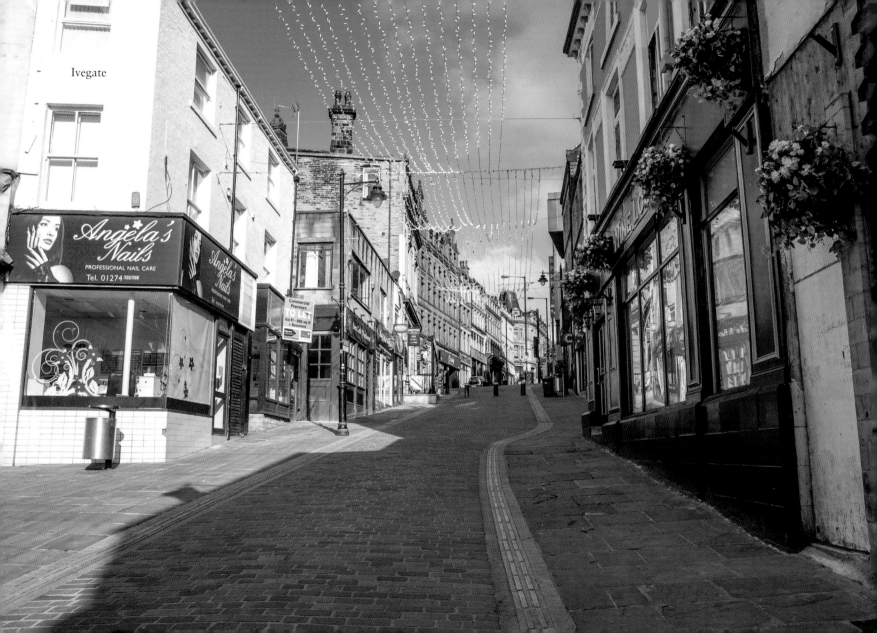

Ivegate

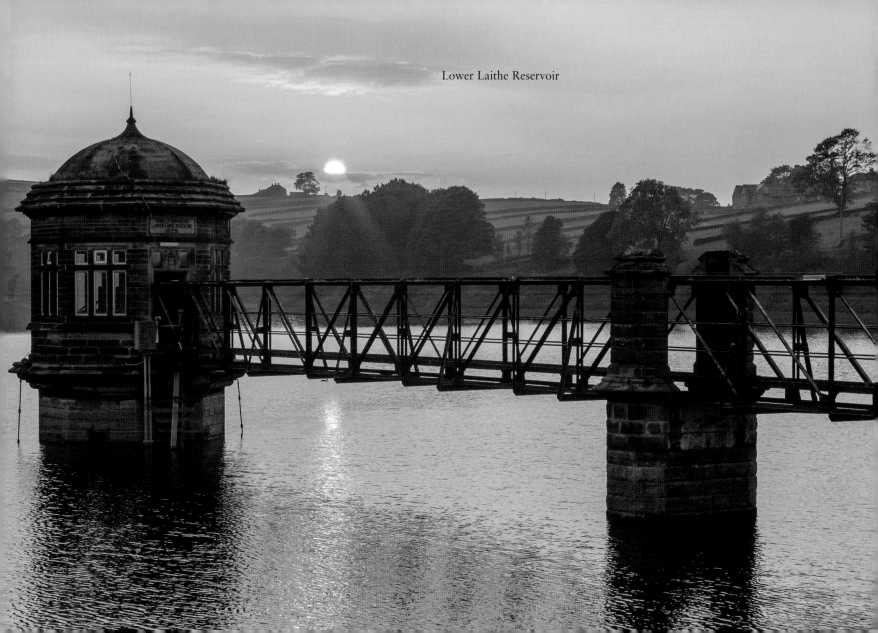

Lower Laithe Reservoir

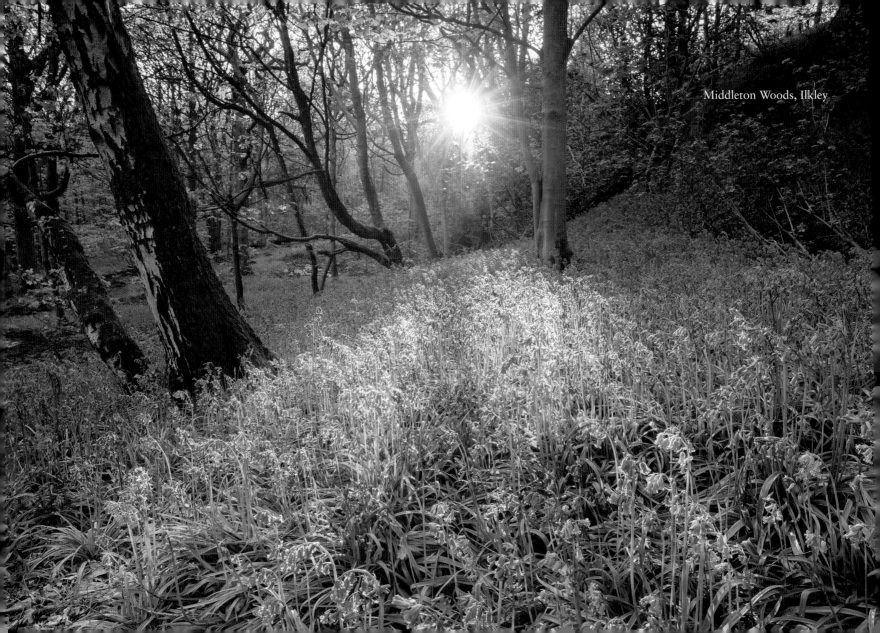

Middleton Woods, Ilkley

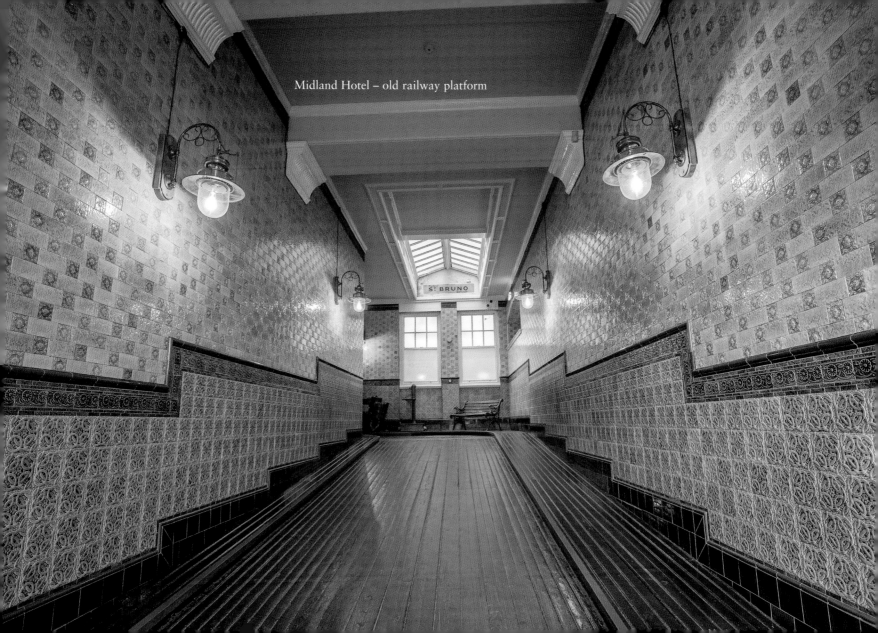

Midland Hotel – old railway platform

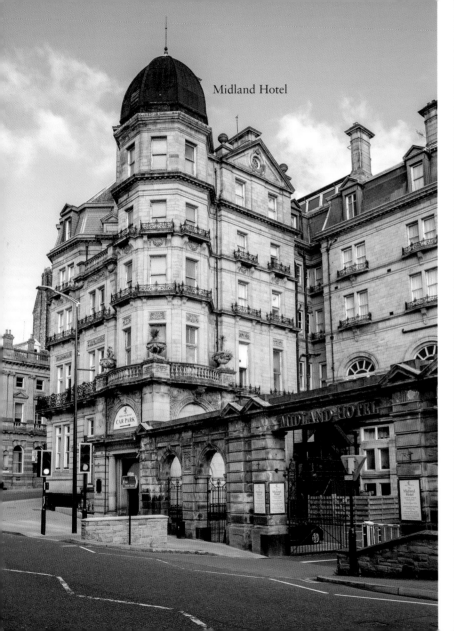

Midland Hotel

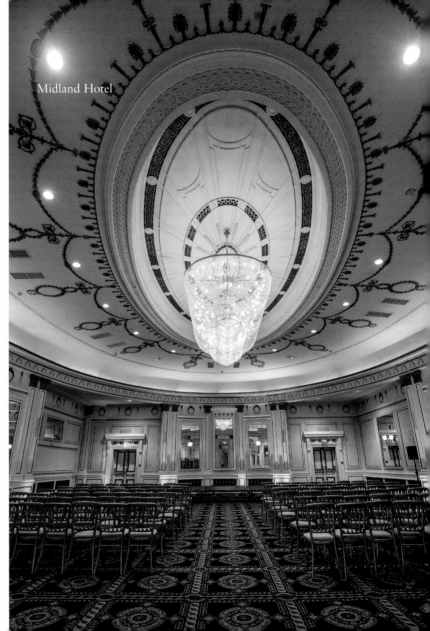

Midland Hotel

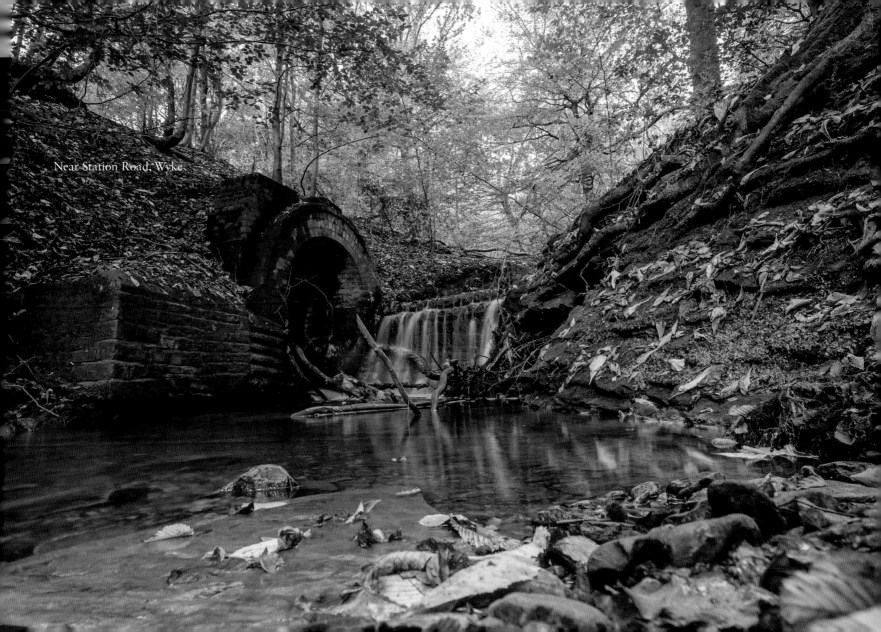

Near Station Road, Wyke

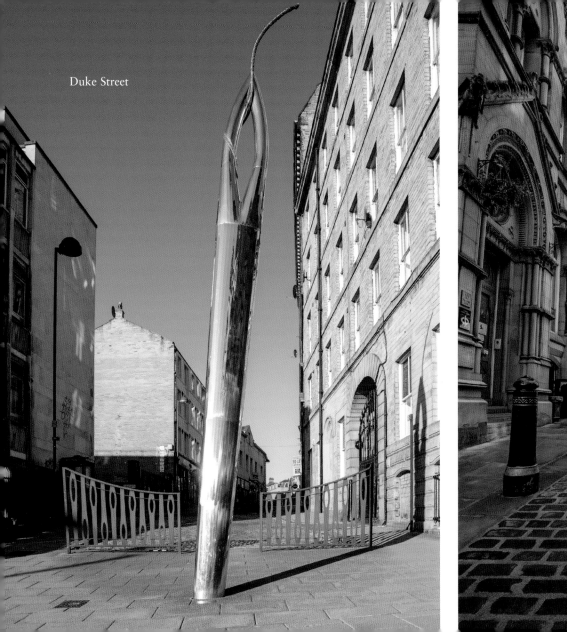

Duke Street

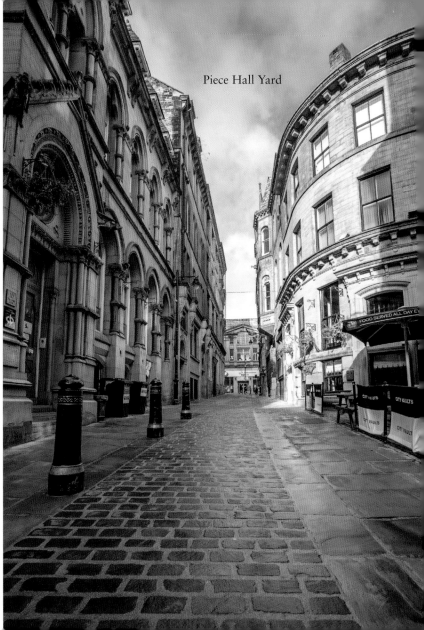

Piece Hall Yard

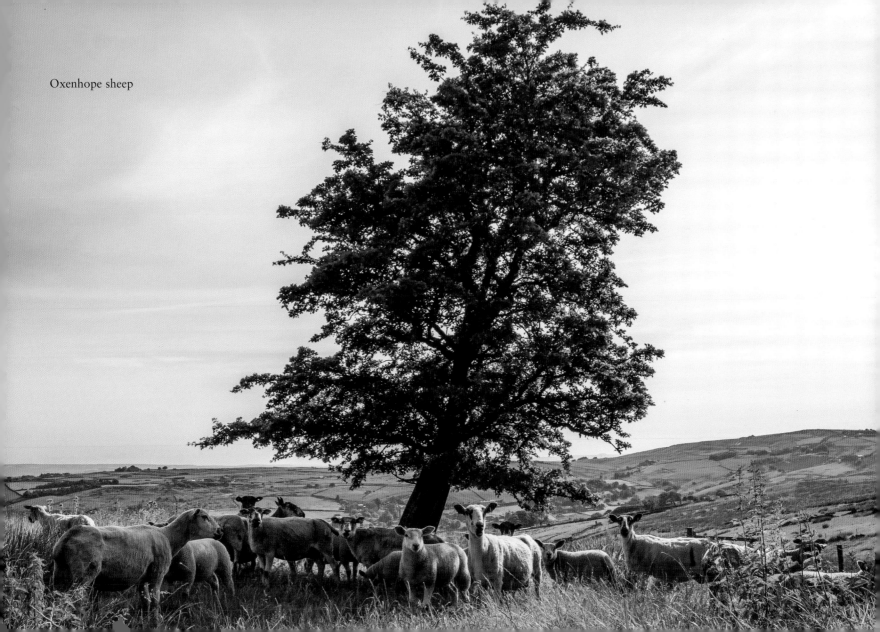

Oxenhope sheep

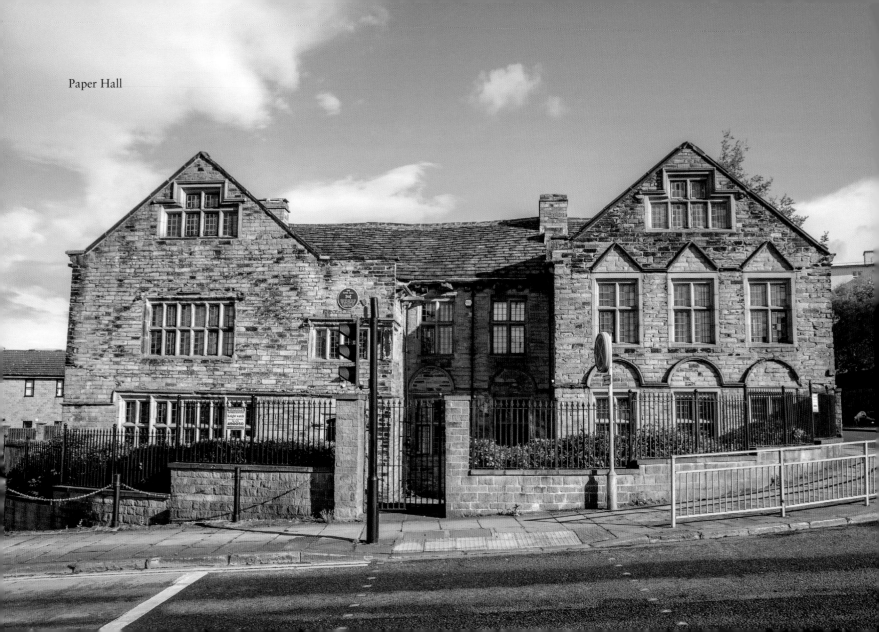

Paper Hall

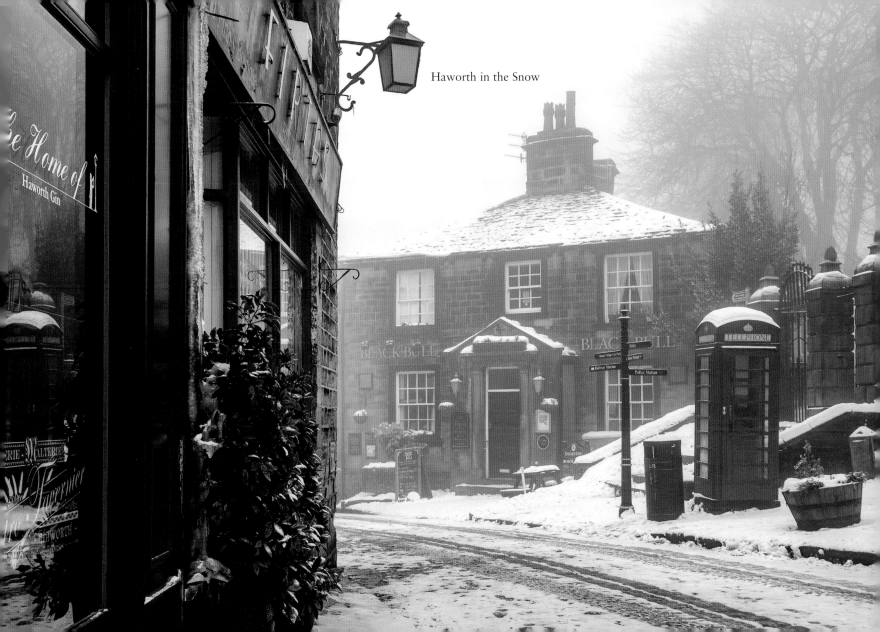

Haworth in the Snow

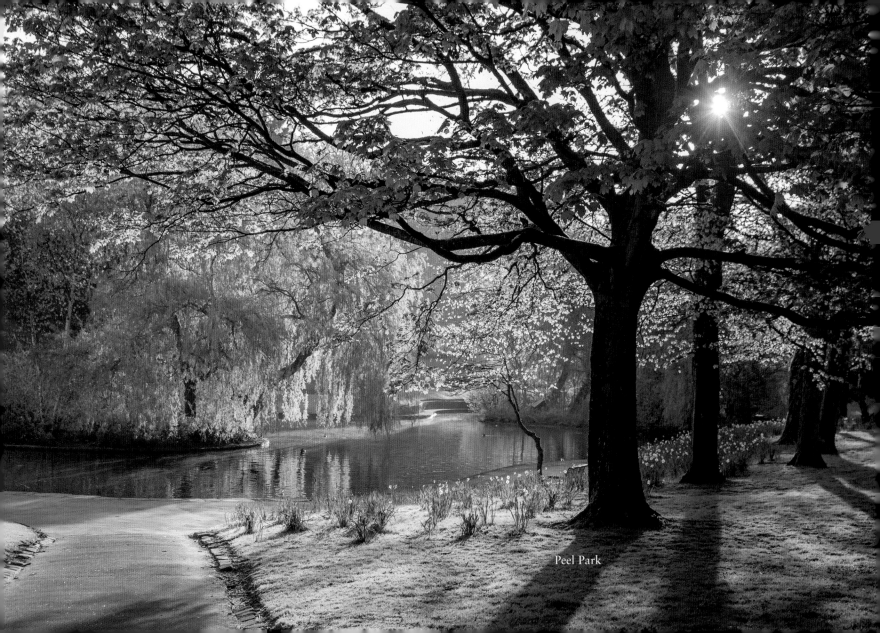

Peel Park

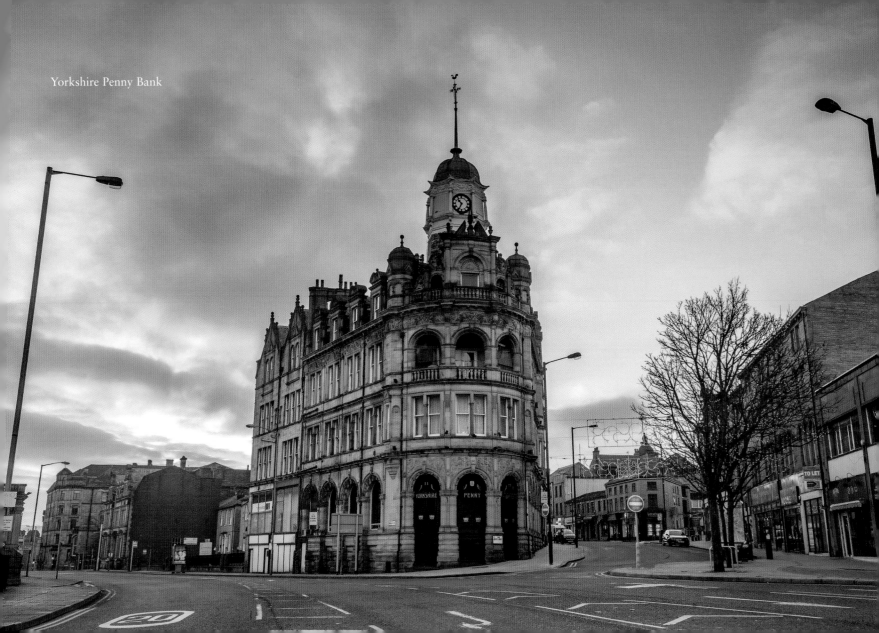

Yorkshire Penny Bank

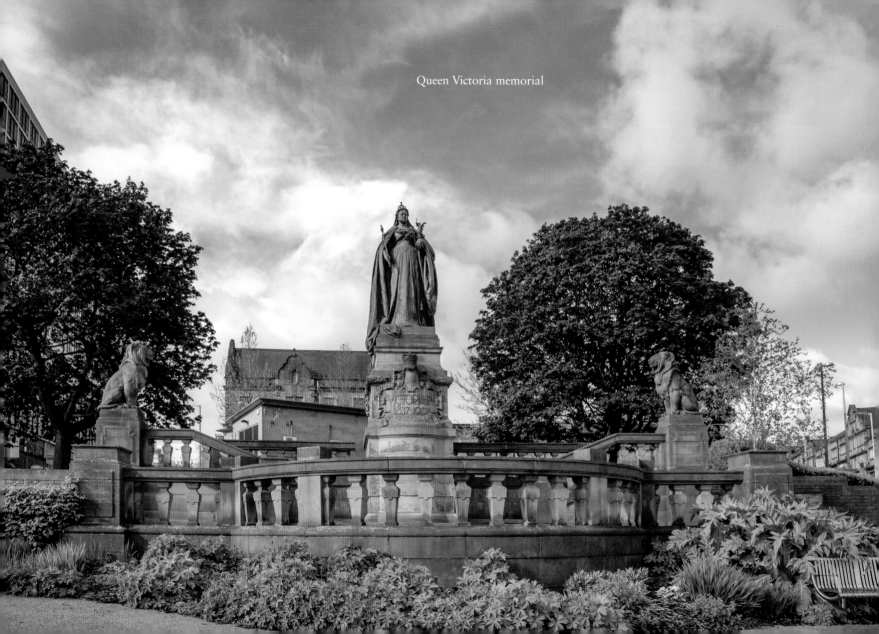

Queen Victoria memorial

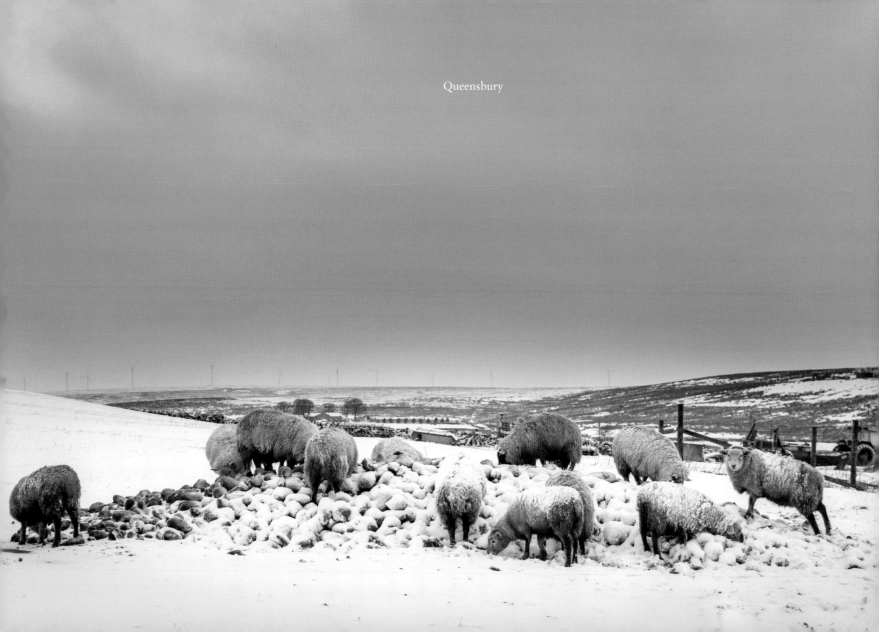

Queensbury

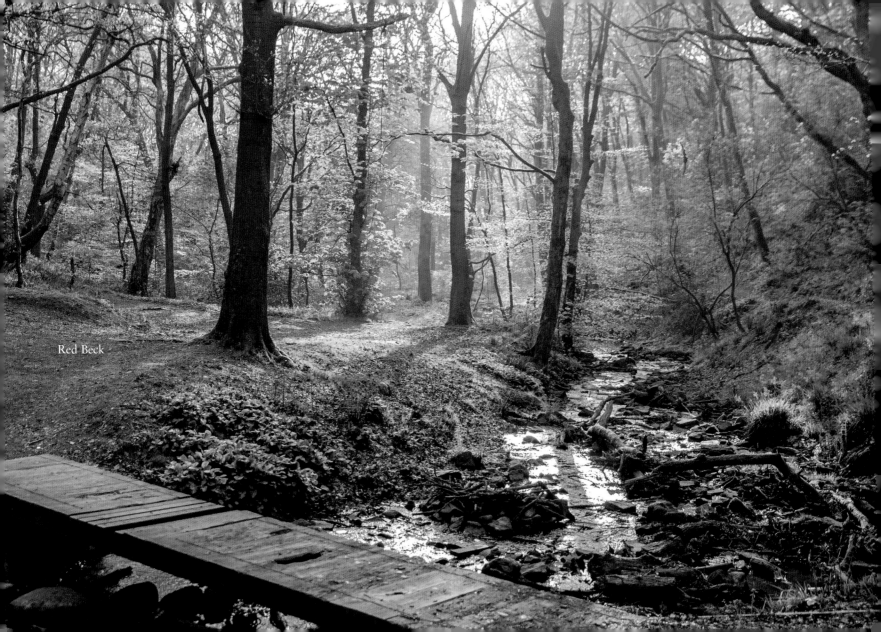

Red Beck

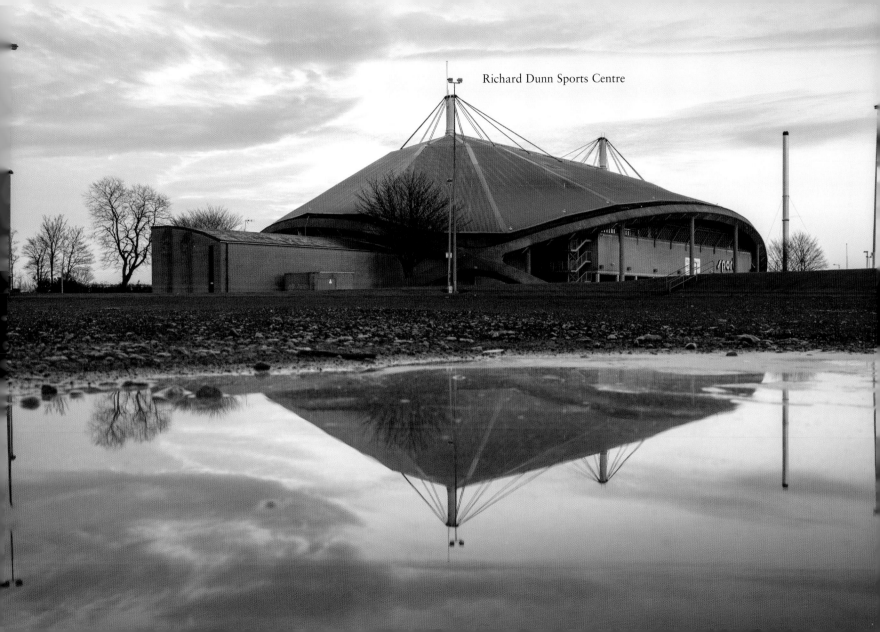

Richard Dunn Sports Centre

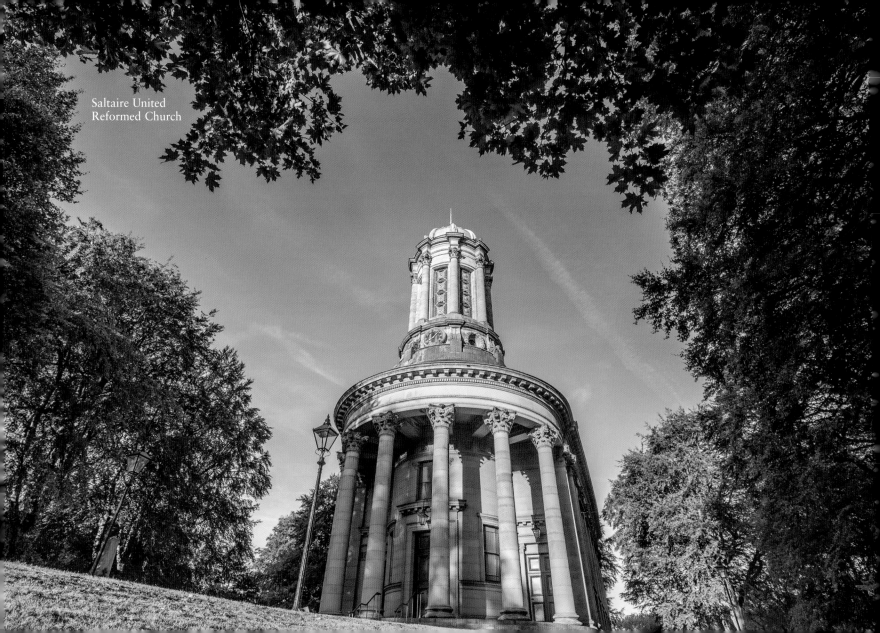

Saltaire United
Reformed Church

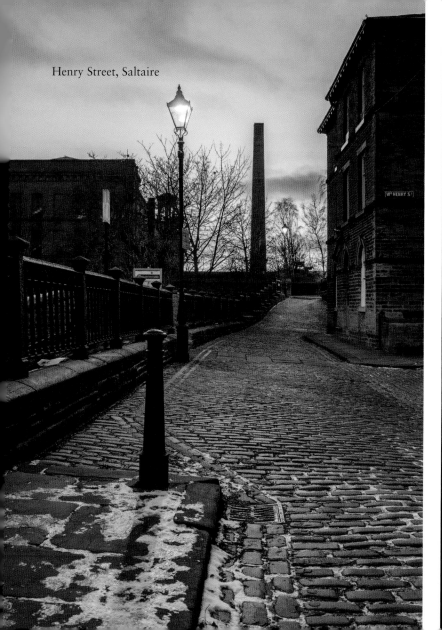

Henry Street, Saltaire

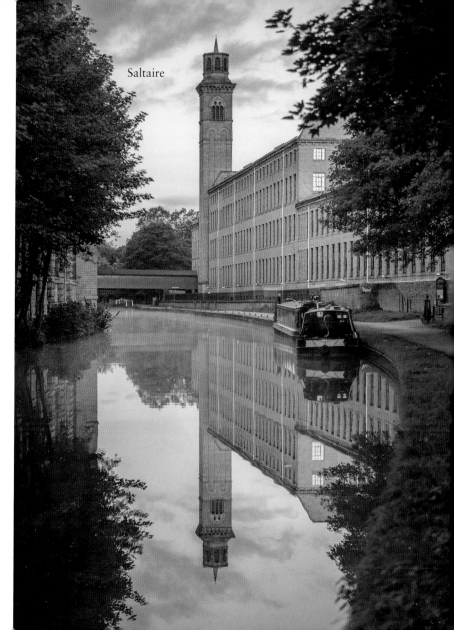

Saltaire

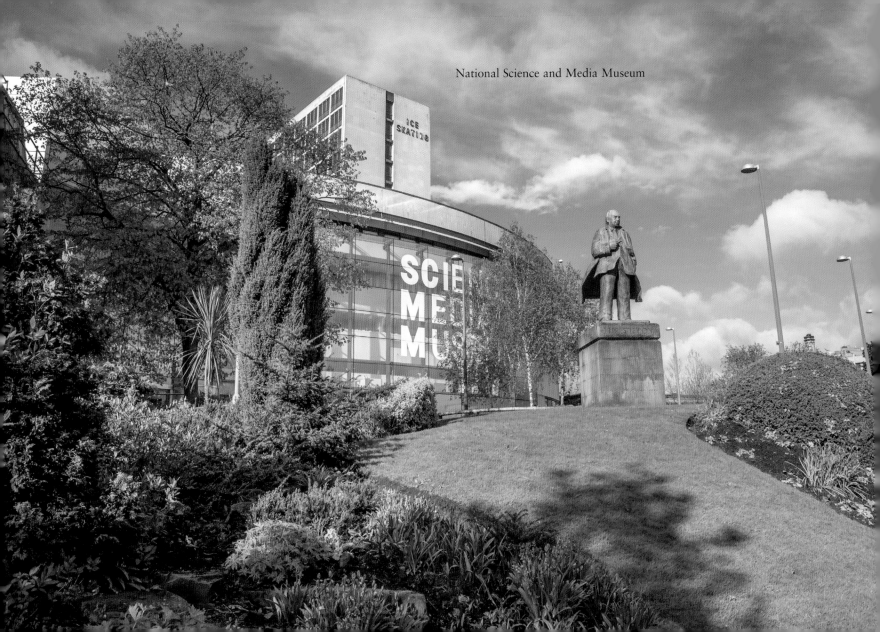

National Science and Media Museum

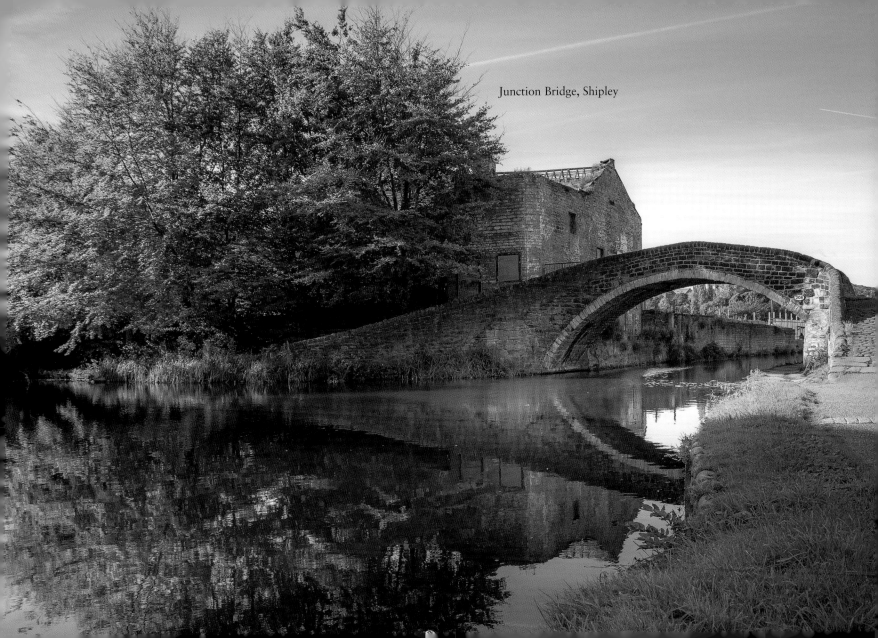

Junction Bridge, Shipley

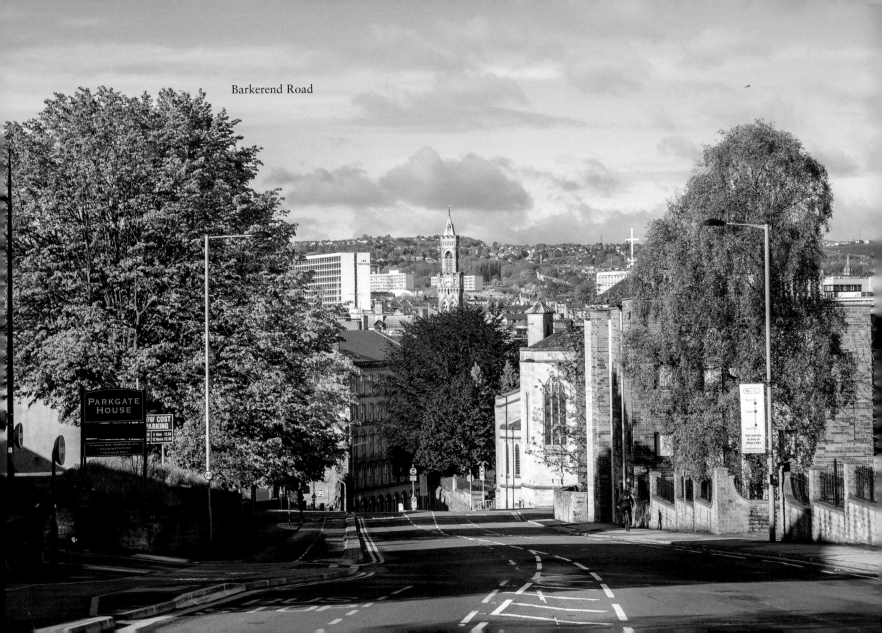

Barkerend Road

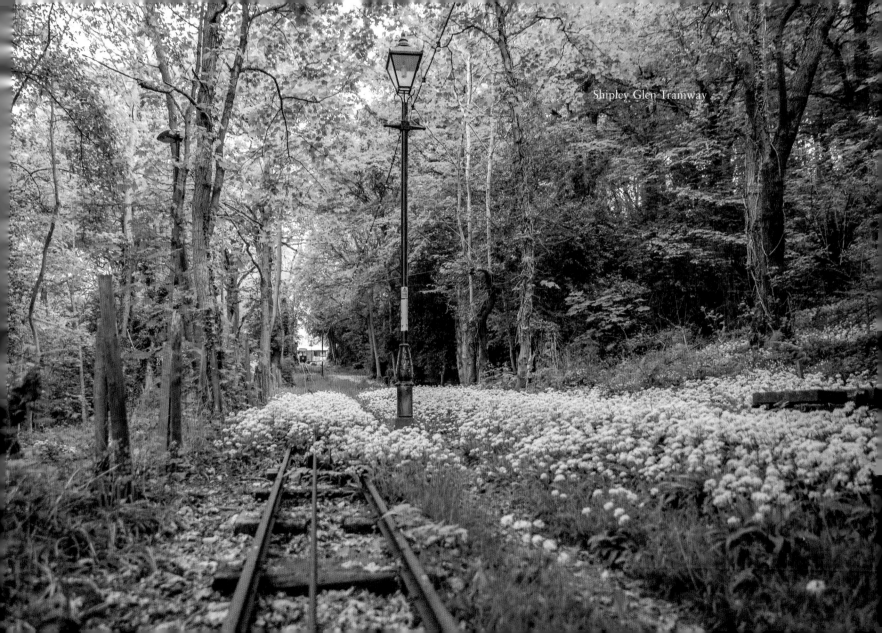

Shipley Glen Tramway

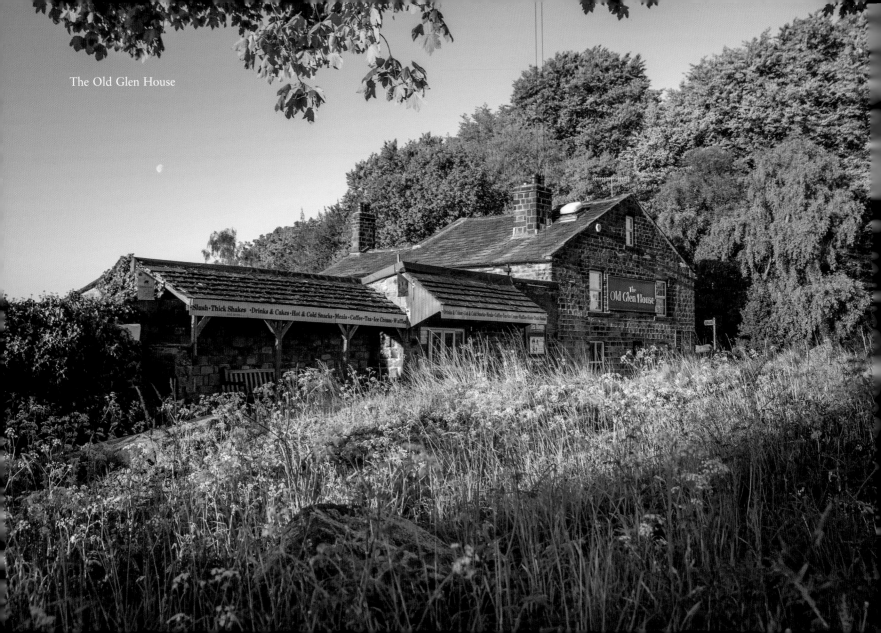

The Old Glen House

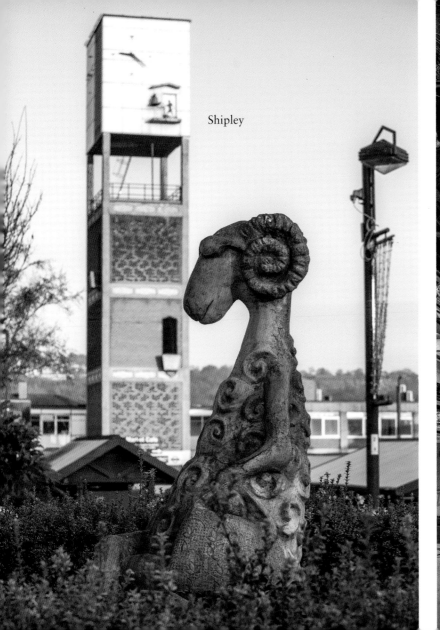

Shipley

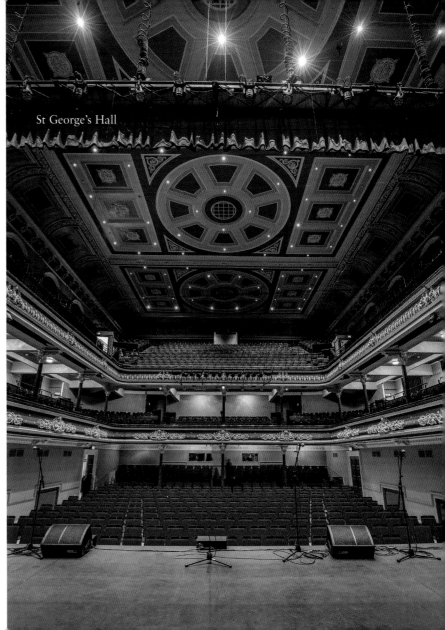

St George's Hall

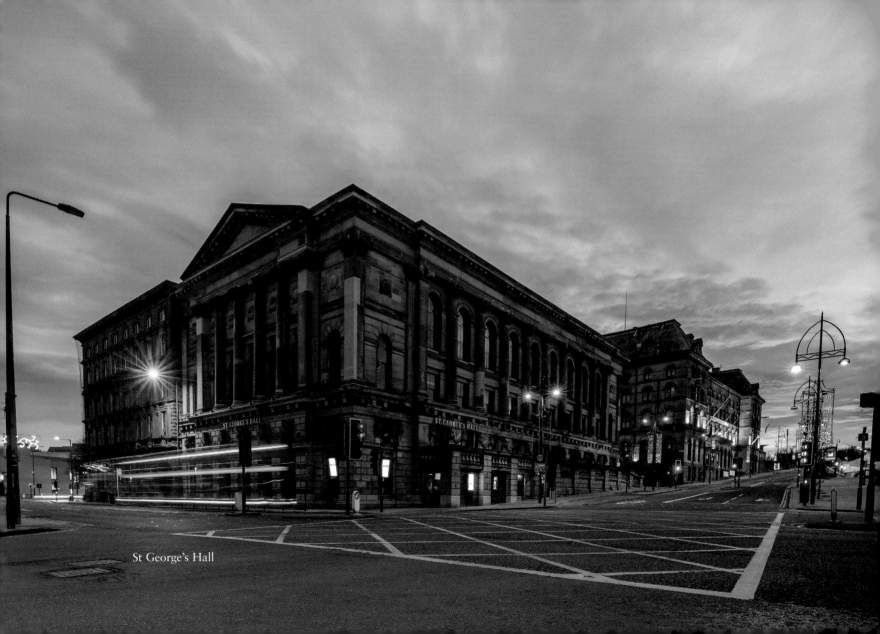

St George's Hall

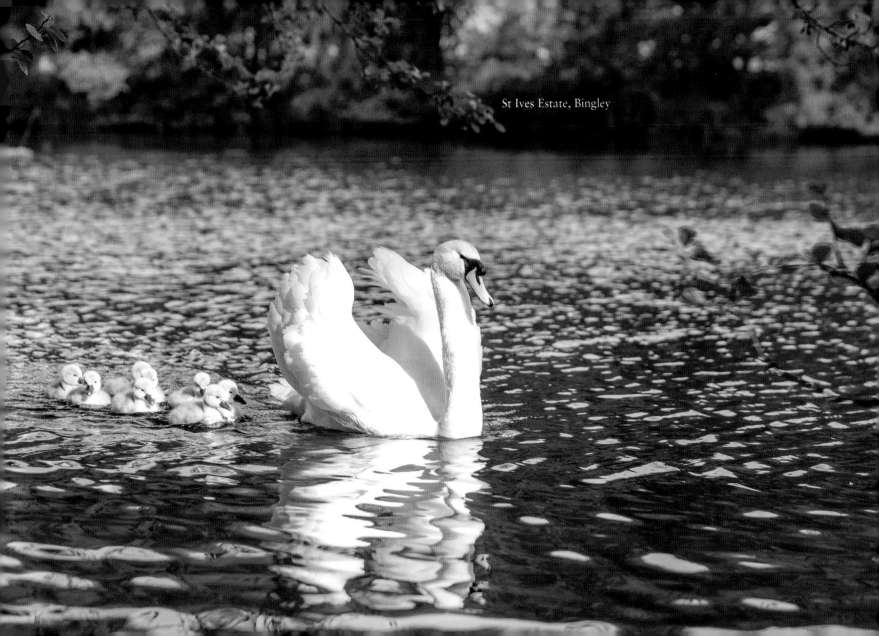

St Ives Estate, Bingley

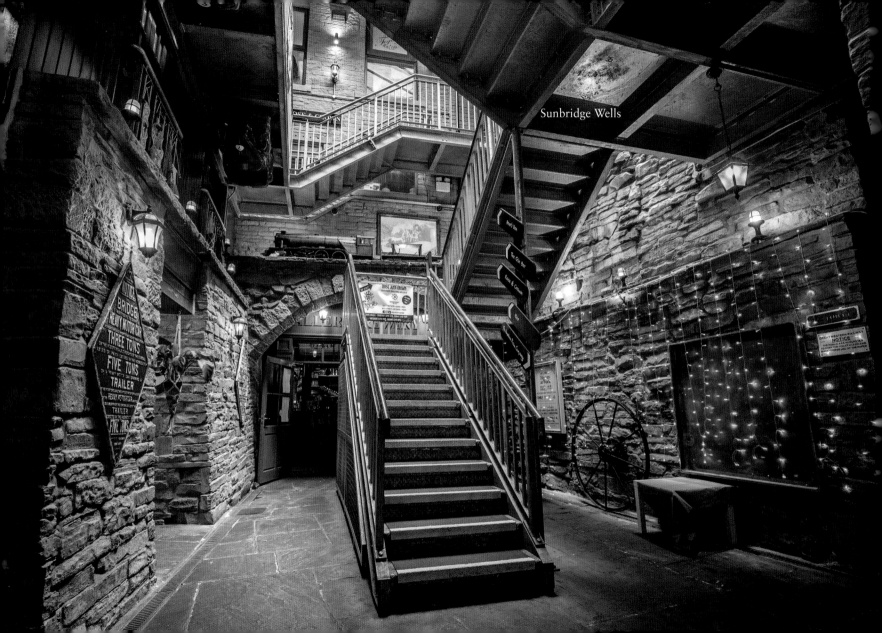

Sunbridge Wells

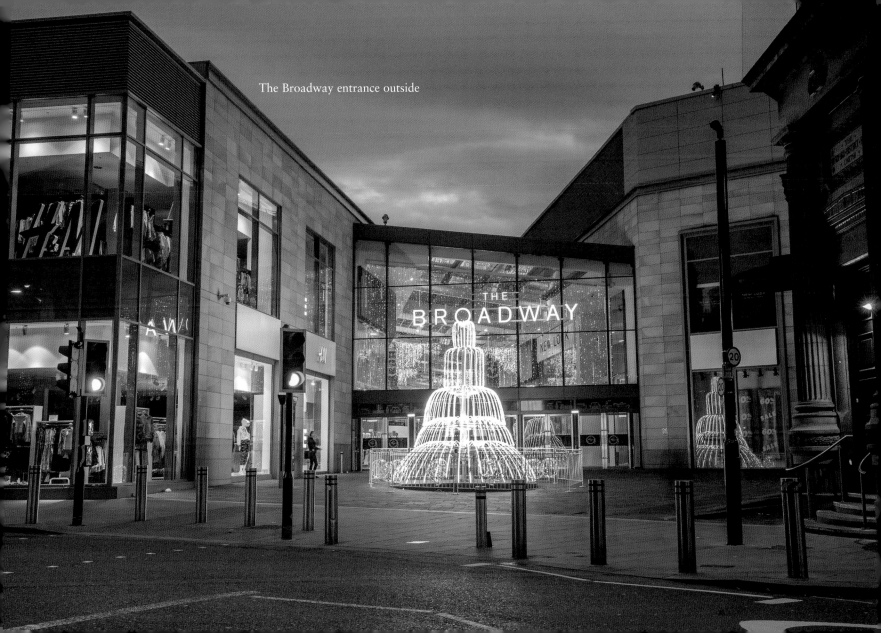

The Broadway entrance outside

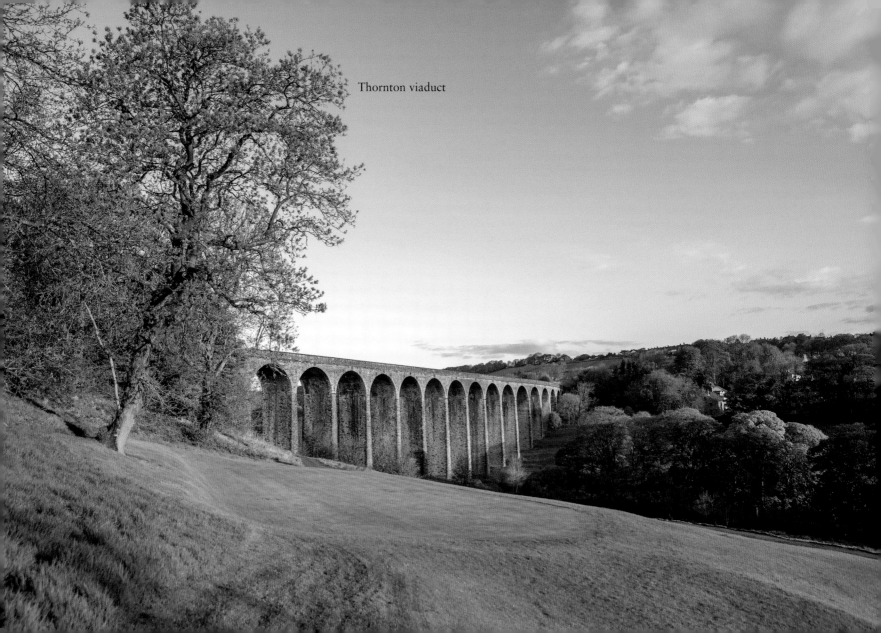

Thornton viaduct

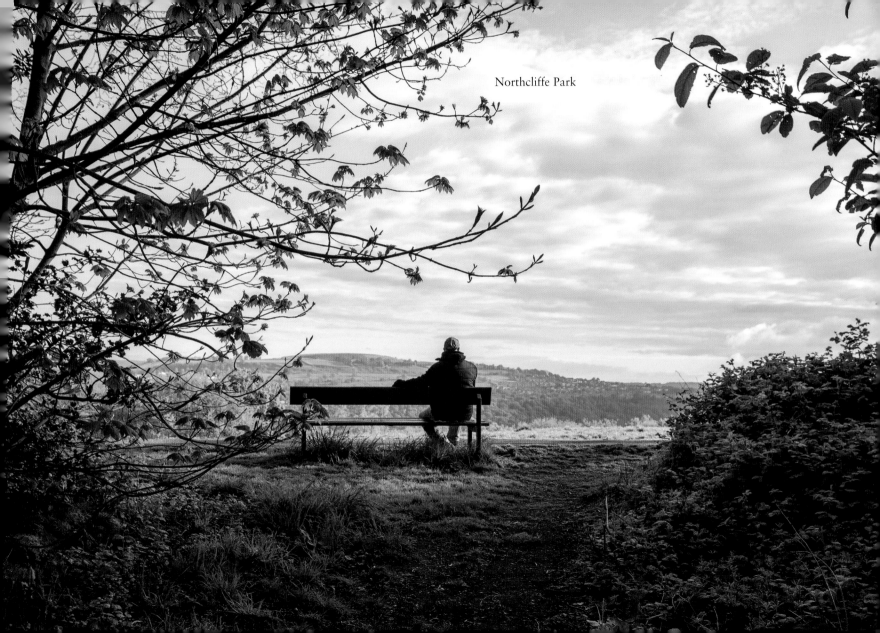

Northcliffe Park

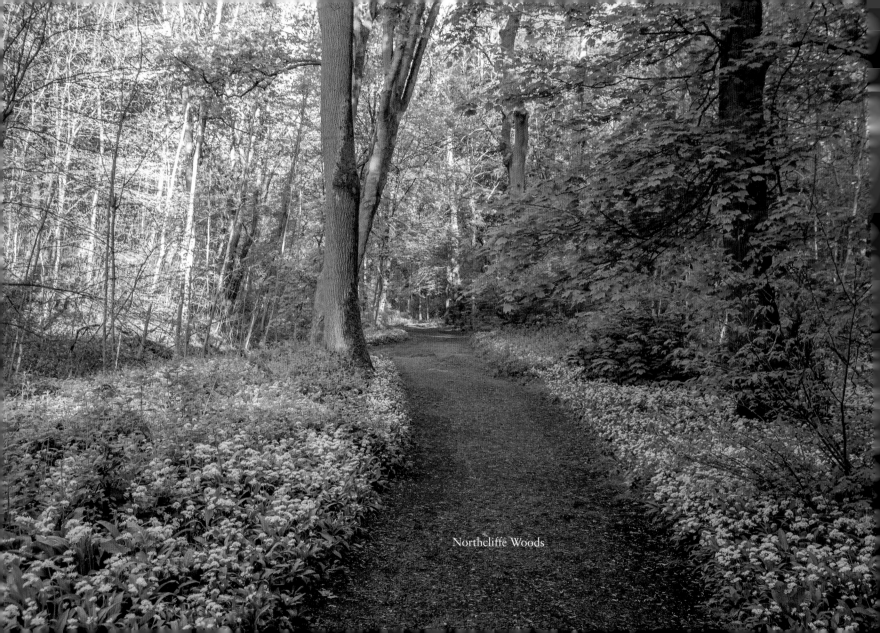
Northcliffe Woods

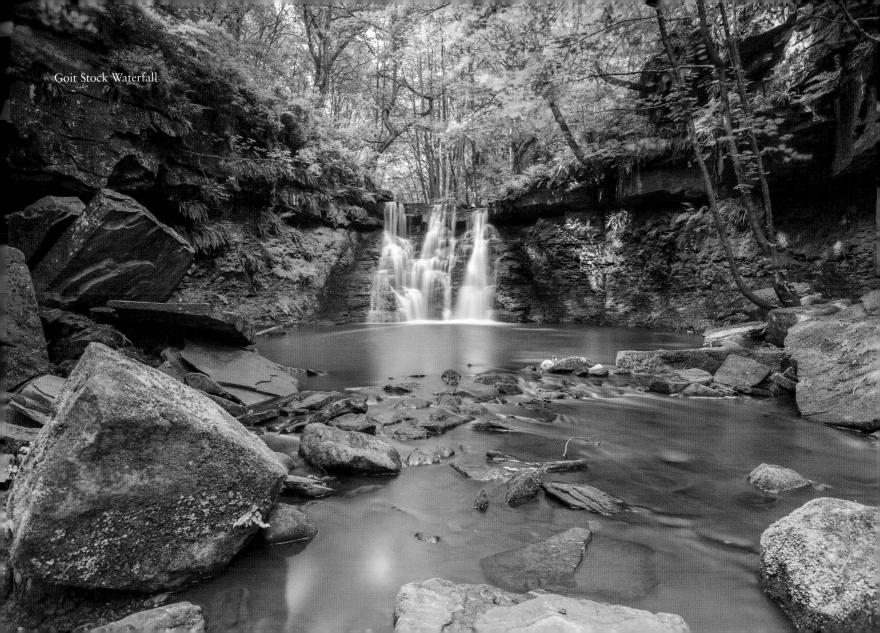

Goit Stock Waterfall

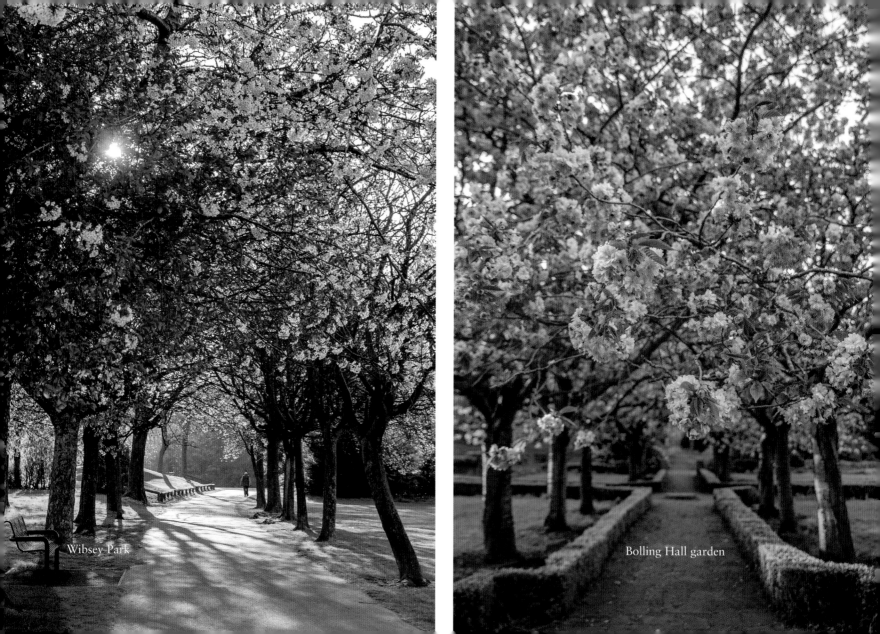

Wibsey Park

Bolling Hall garden

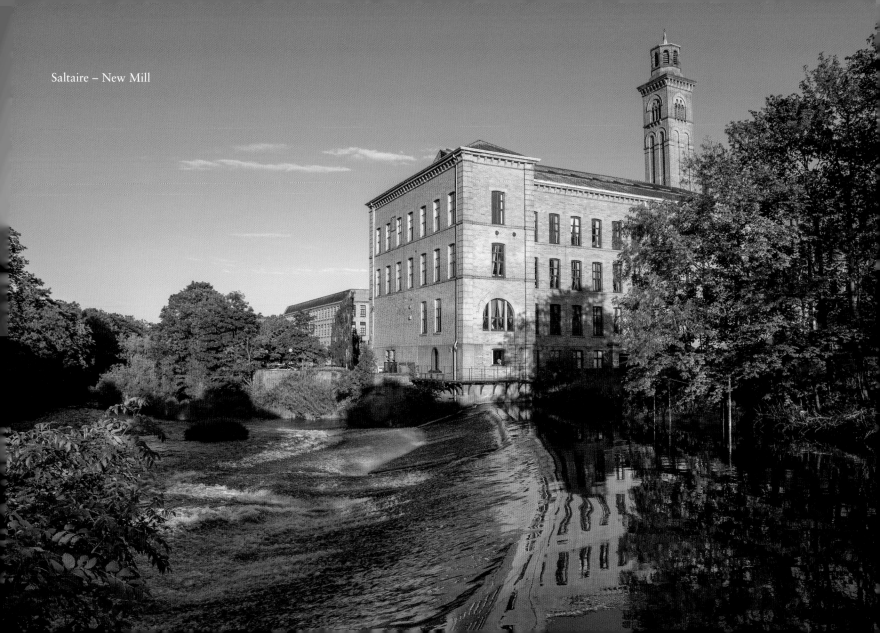

Saltaire – New Mill

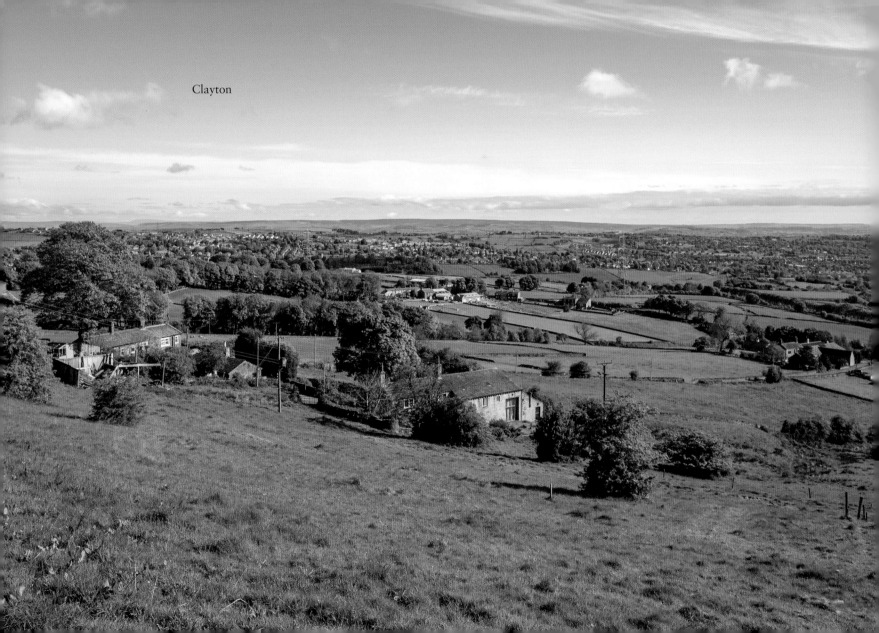

Clayton

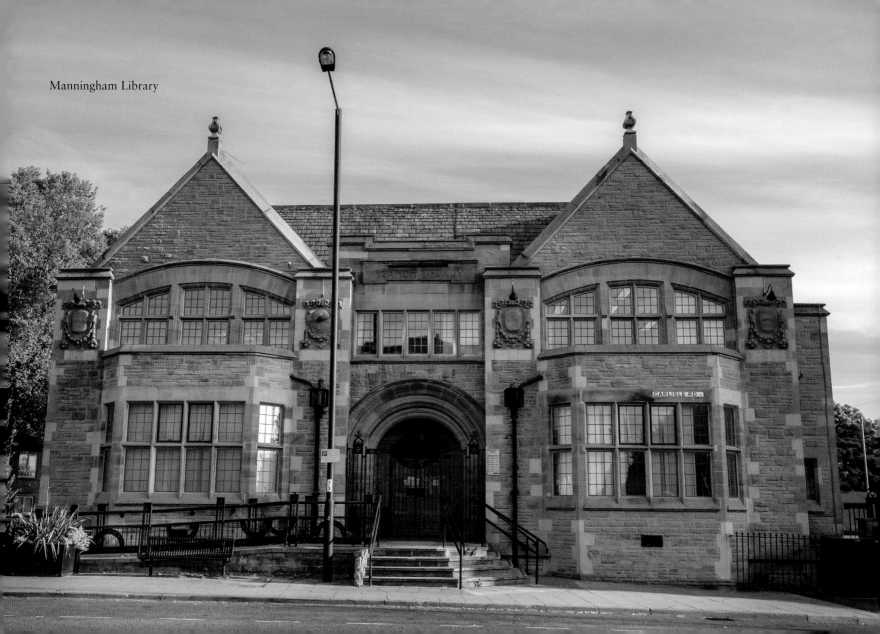

Manningham Library

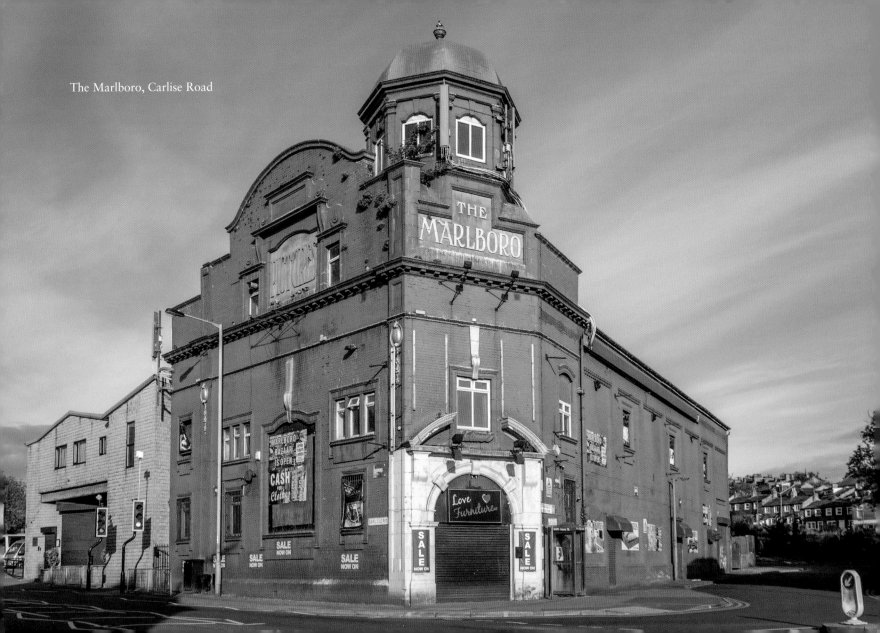

The Marlboro, Carlise Road

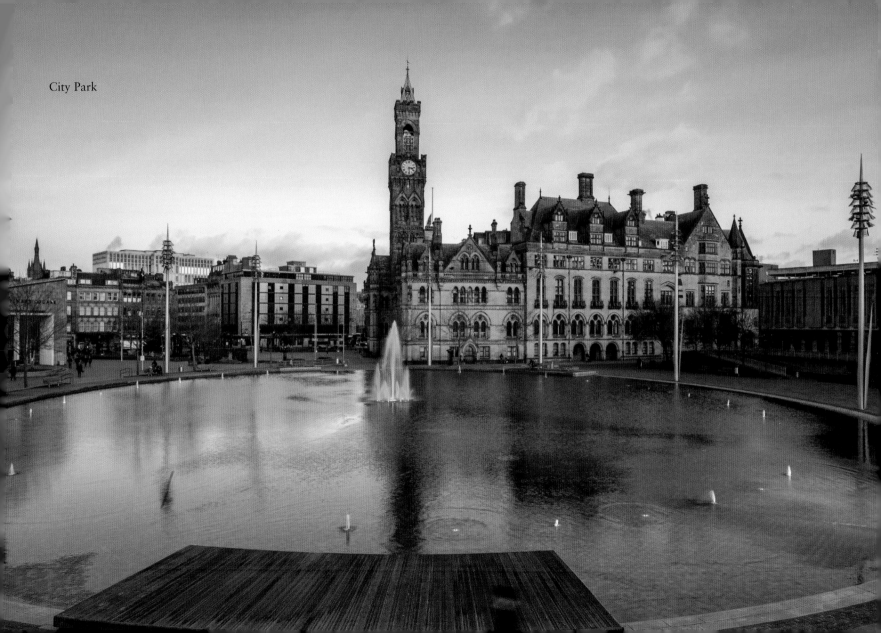

City Park

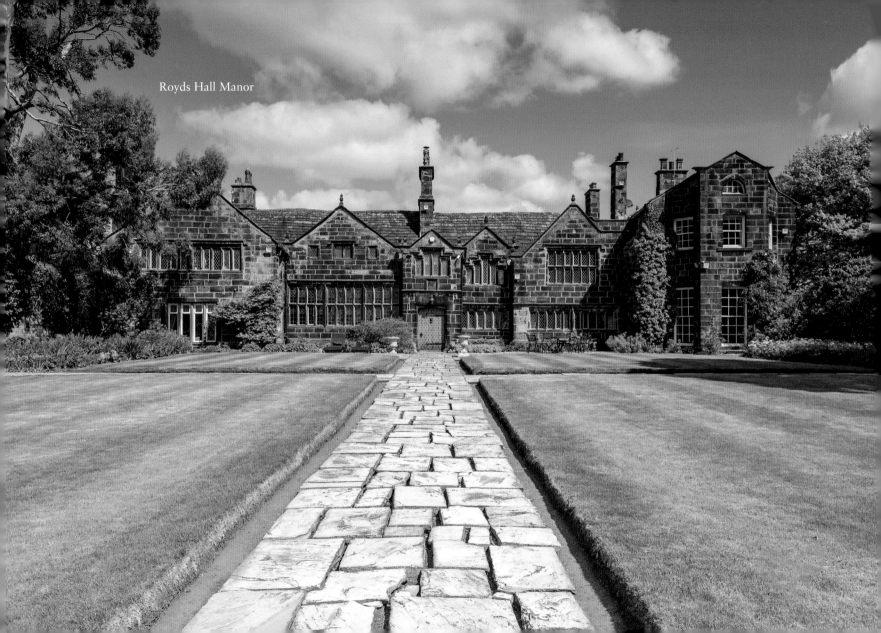

Royds Hall Manor

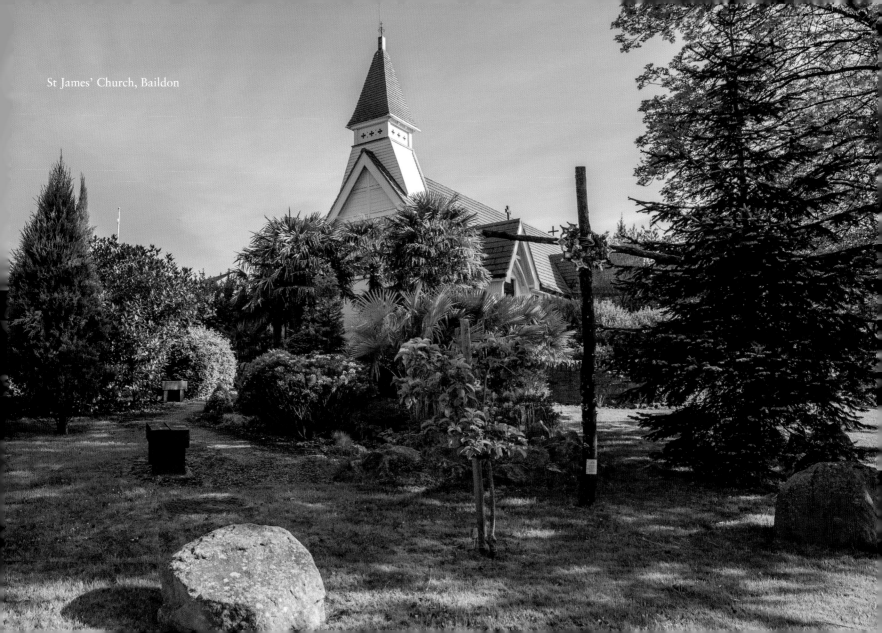

St James' Church, Baildon

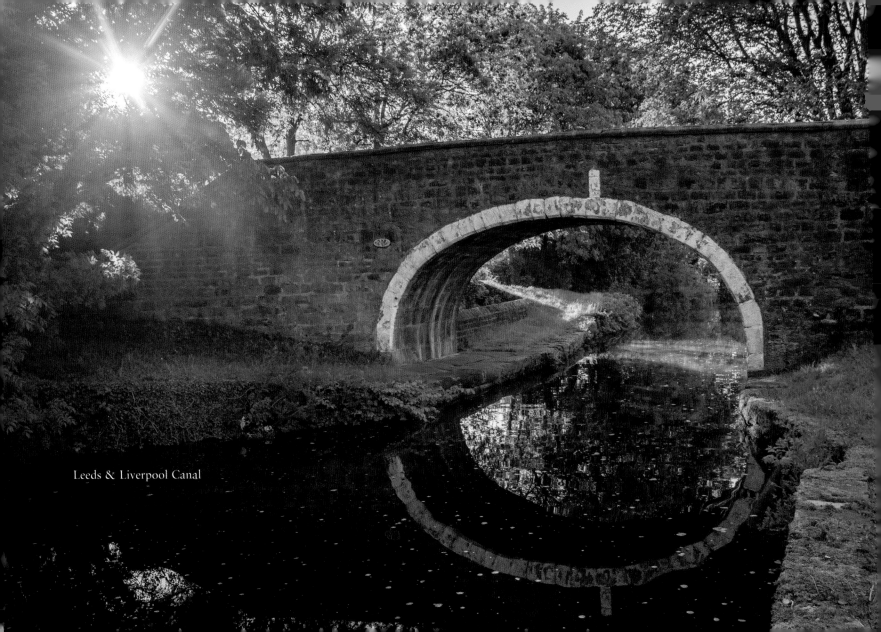

Leeds & Liverpool Canal

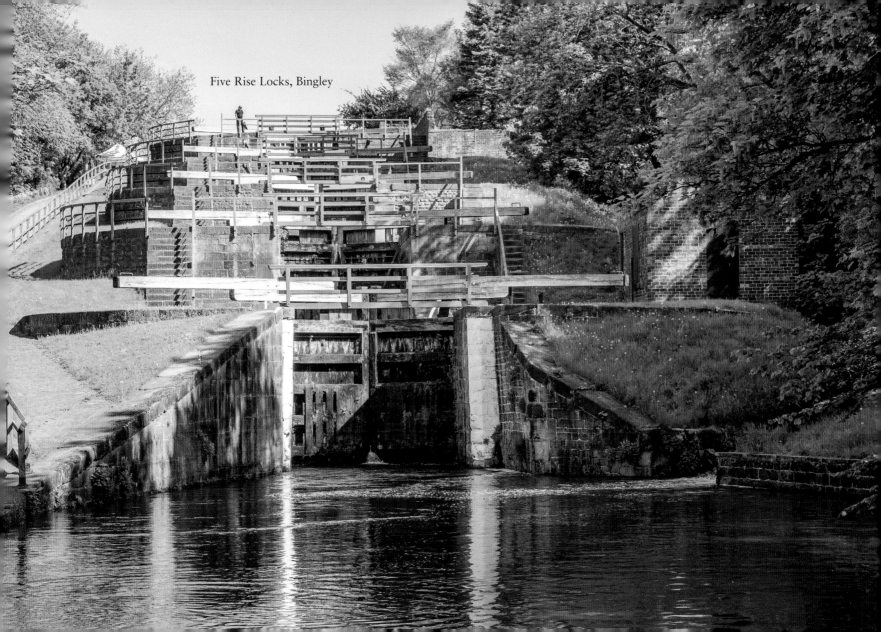

Five Rise Locks, Bingley

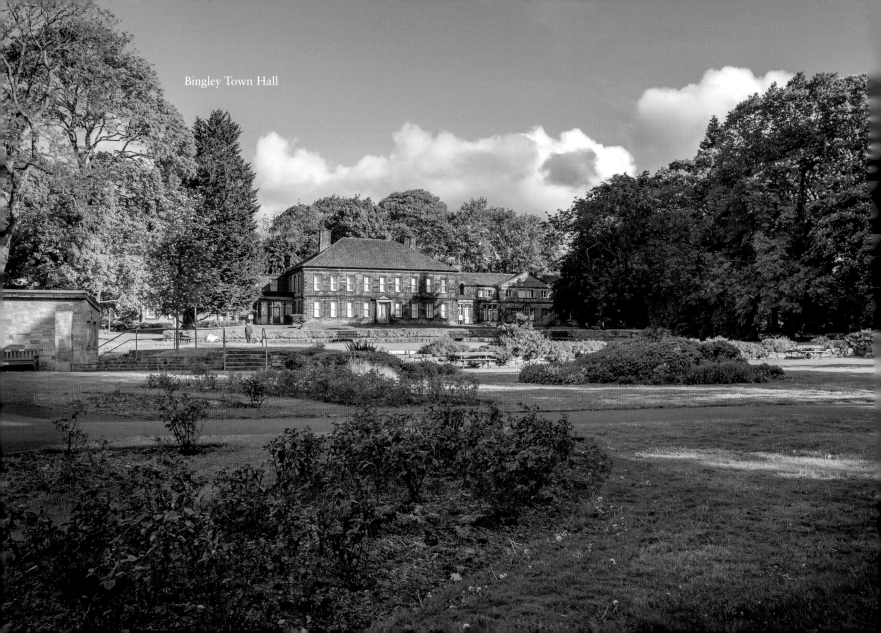

Bingley Town Hall

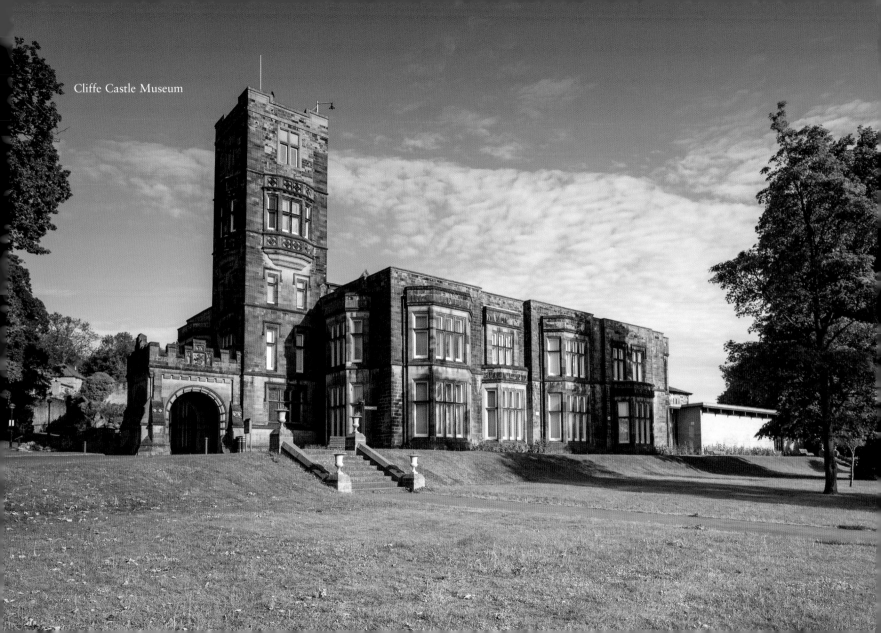

Cliffe Castle Museum

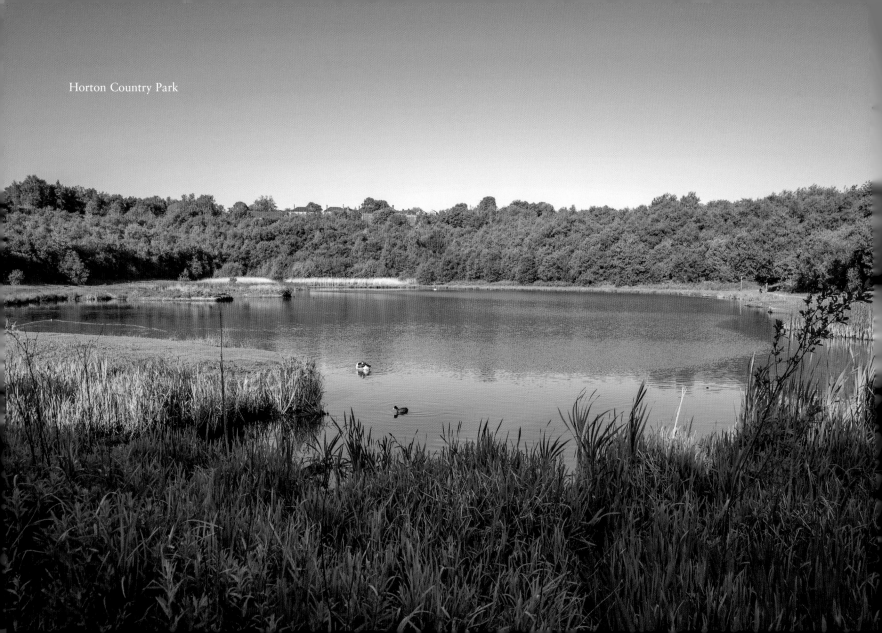

Horton Country Park

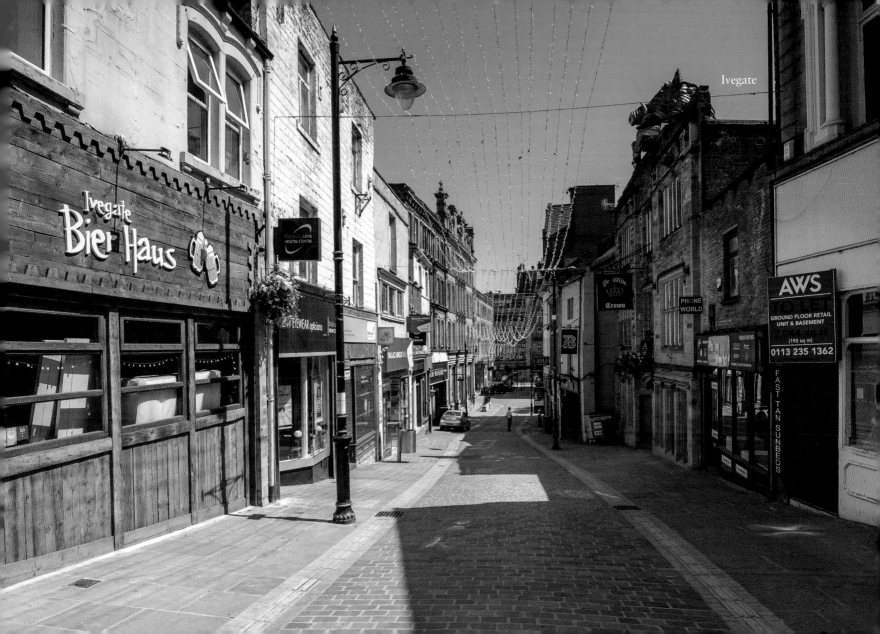

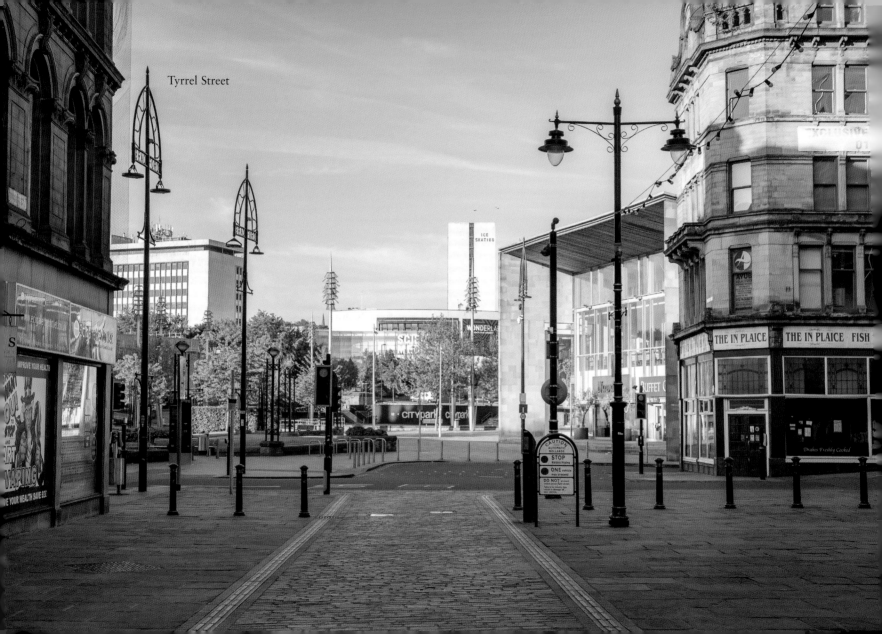

Tyrrel Street

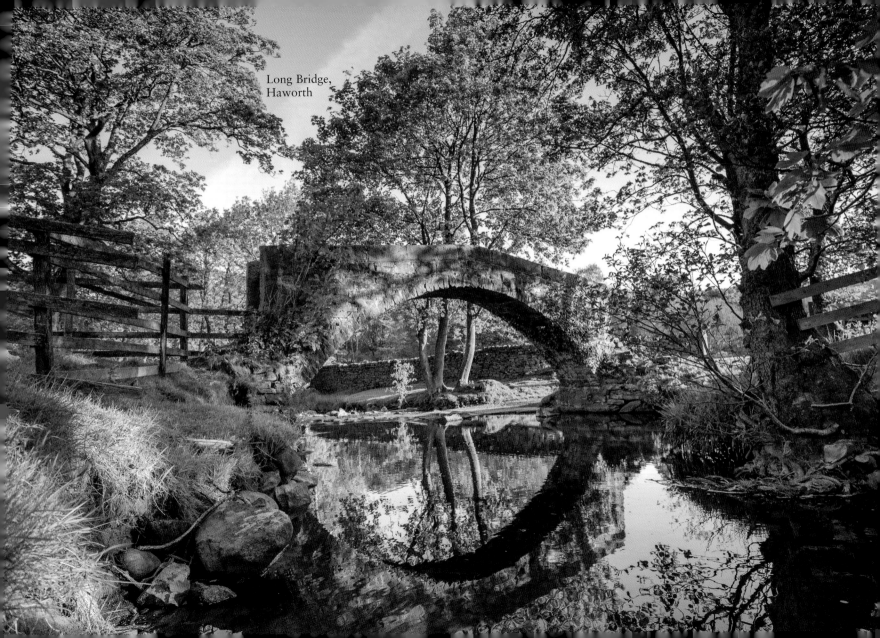

Long Bridge,
Haworth

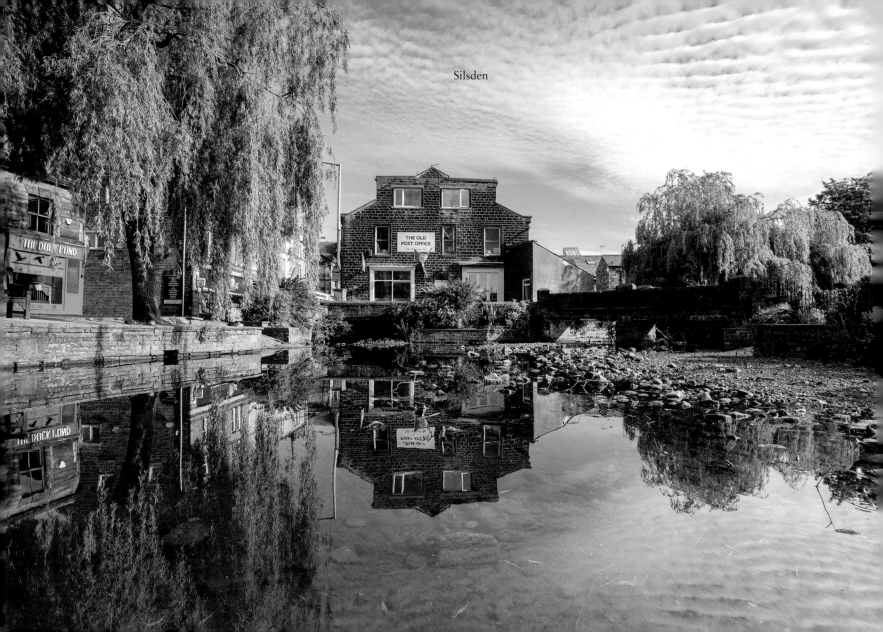

Silsden

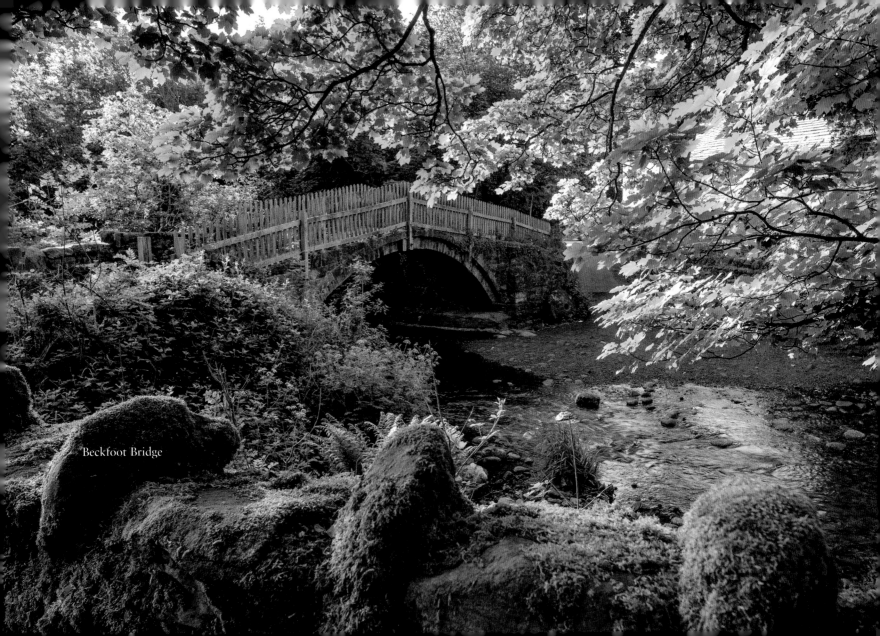

Beckfoot Bridge

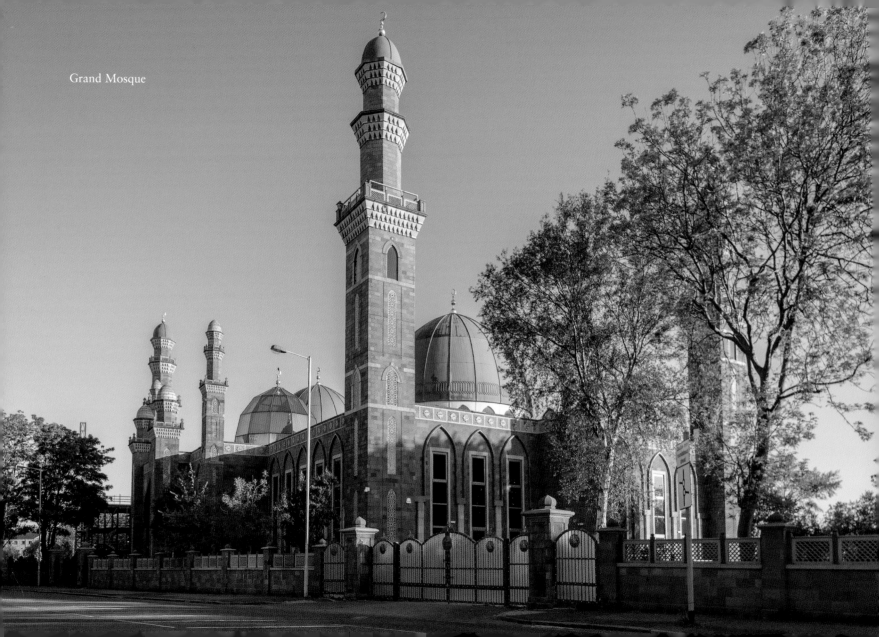

Grand Mosque

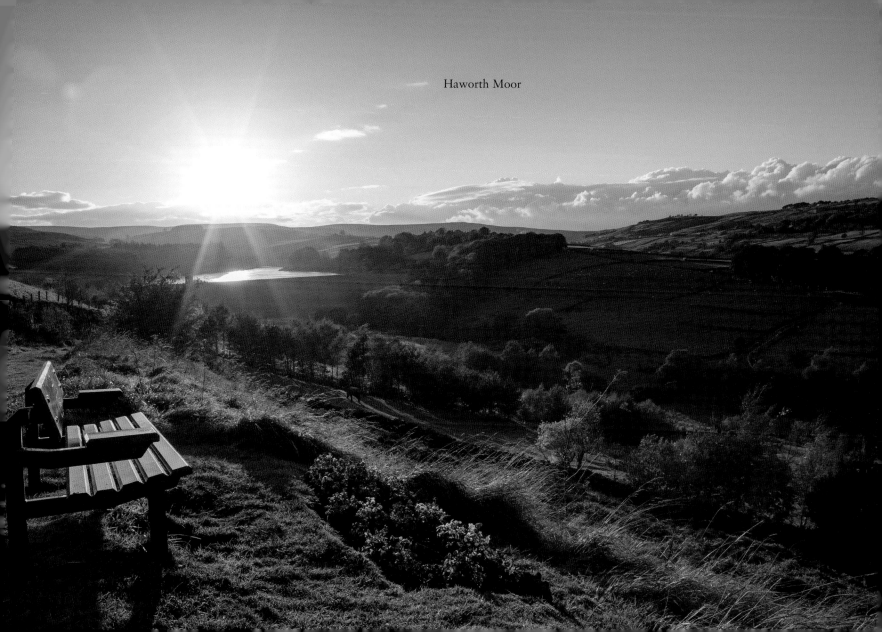

Haworth Moor

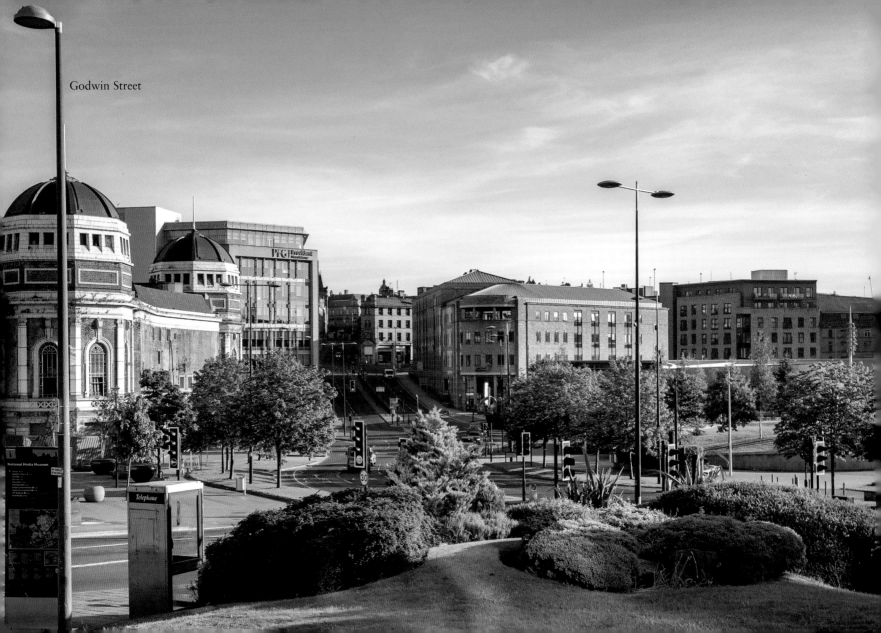

Godwin Street

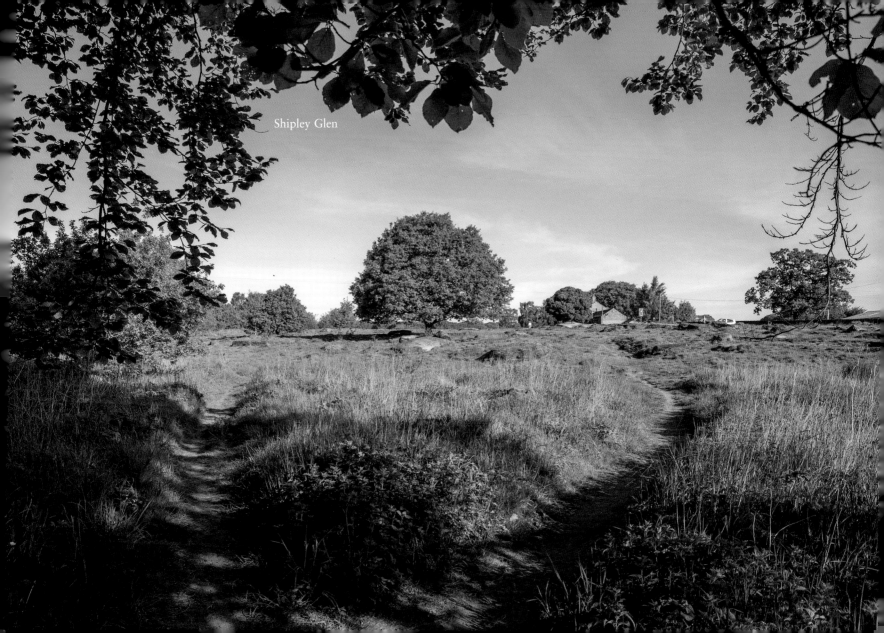
Shipley Glen

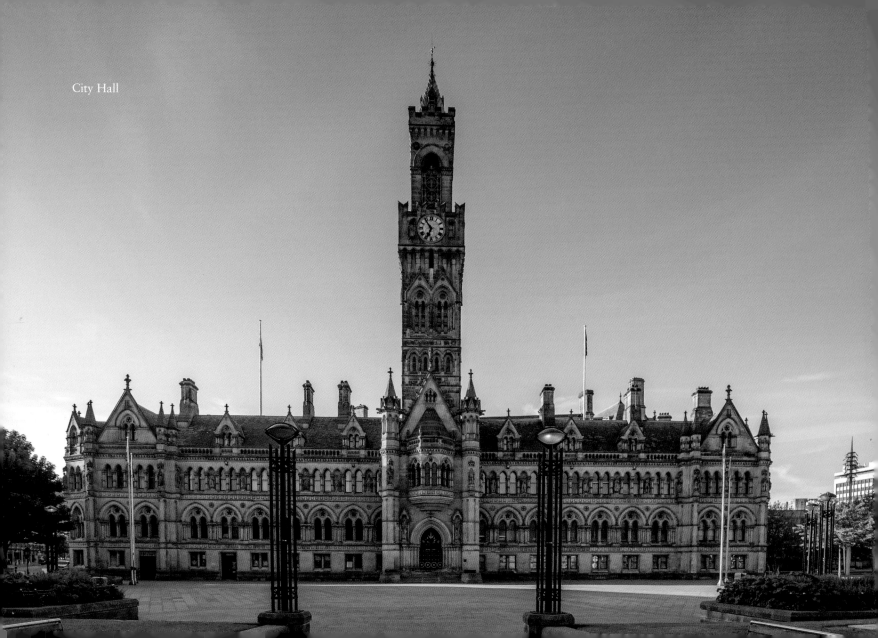

City Hall

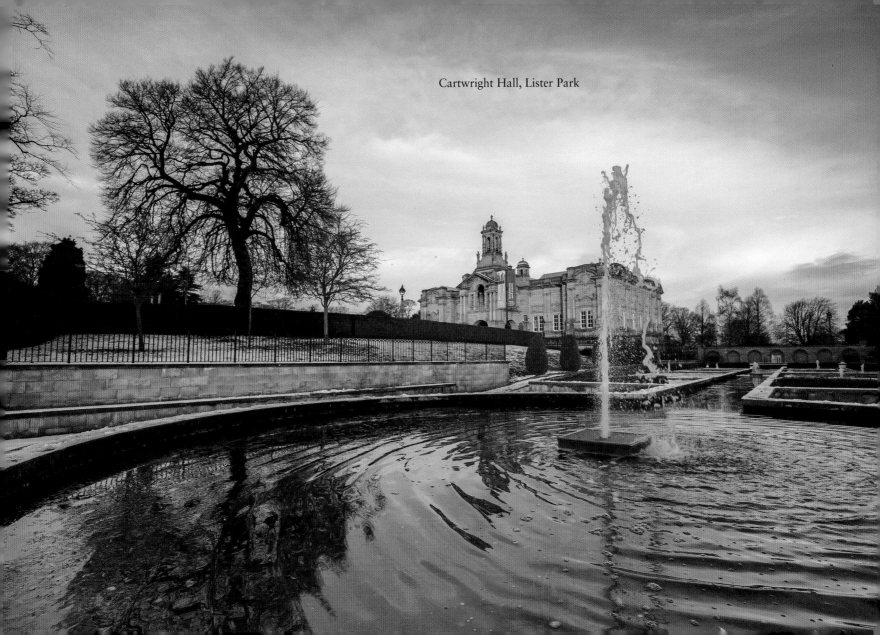

Cartwright Hall, Lister Park

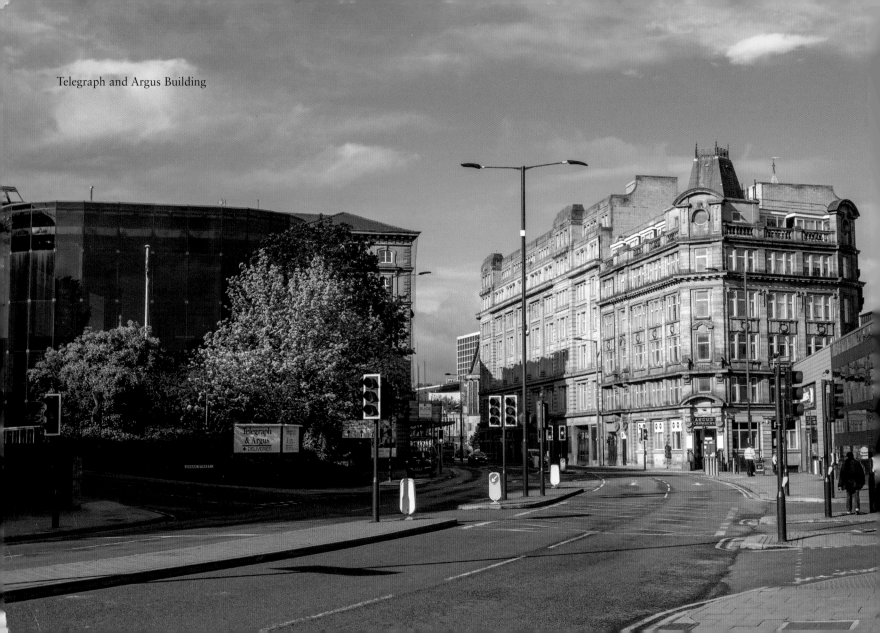

Telegraph and Argus Building